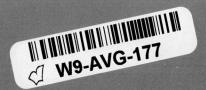
W9-AVG-177

Imitate Touch, 1989. Watercolor, 26 x 41 in.
Courtesy Mai 36 Galerie, Lucerne.

PUBLIC MIND:

LES LEVINE'S MEDIA SCULPTURE
AND MASS AD CAMPAIGNS

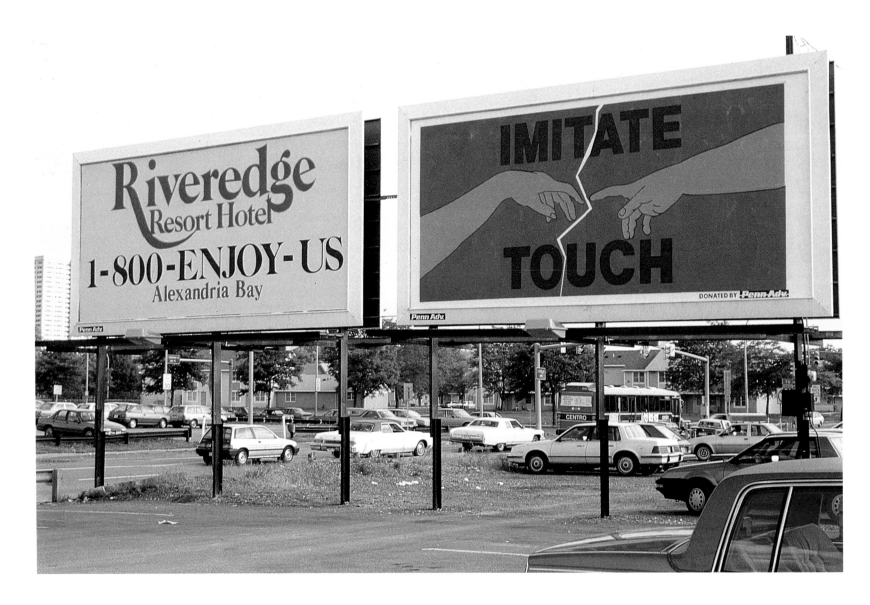

Imitate Touch, September 1990. In situ documentary photograph of the Syracuse, New York, billboard project, 120 x 252 in.

PUBLIC MIND:

VISUAL & PERFORMING ARTS
CHICAGO PUBLIC LIBRARY
400 SOUTH STATE STREET
CHICAGO, IL 60605

LES LEVINE'S MEDIA SCULPTURE AND MASS AD CAMPAIGNS 1969-1990

CURATED BY DOMINIQUE NAHAS

EVERSON MUSEUM OF ART

N6537. L428 N3 1990

Public Mind: Les Levine's Media Sculpture and
Mass Ad Campaigns 1969-1990 is made
possible, in part, with funds from the National
Endowment for the Arts, a federal agency, and public
funds from the New York State Council on the Arts.
Additional support has been received from Penn
Advertising.

This publication was prepared on the occasion of
the exhibition Public Mind: Les Levine's Media
Sculpture and Mass Ad Campaigns 1969-1990
held at Everson Museum of Art from September 14
through November 11, 1990.

Copyright © 1990 Everson Museum of Art.

All rights reserved. No reproduction of this book
in whole or in part or in any form may be made
without written authorization of the copyright owner.

ISBN: 0-914407-14-7

Library of Congress Catalog Number: 90-084035

Production editor, Thomas Piché Jr.

Designed by Mark Whistler and Anne Dutlinger

Typeset by Patty MacLeish, Computer-at-Large,
in Franklin Gothic

Printed in an edition of 2000 on Mohawk Innovation
by Syracuse Colour Graphics, Ltd.

R03111 27664

VISUAL & PERFORMING ARTS
CHICAGO PUBLIC LIBRARY
400 SOUTH STATE STREET
CHICAGO, IL 60605

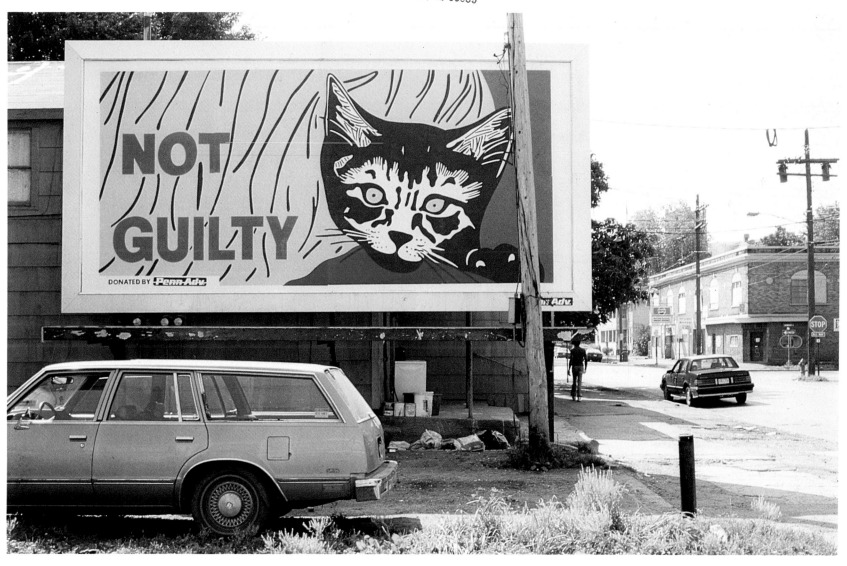

Not Guilty, September 1990. In situ documentary
photograph of the Syracuse, New York, billboard
project, 120 x 252 in.

Artists of ideas and artists of media are relatively recent phenomena in art. Their art is still considered unconventional by the general public, which, nonetheless, takes for granted and absorbs a tremendous amount of media information. The public understands clearly enough the "commercial art" surrounding them on television, in magazines and newspapers, on billboards, and in advertising of all kinds. It was inevitable, I suppose, for an aesthetically and intellectually astute sensibility, with artistic training, to turn the ubiquitous signs and pictures of daily life into art with meaning. This is what Les Levine has done with uncanny skill and with precocious advantage. Venturesome and experimental, the artist has not only given us something attractive to contemplate but, through new and disconcerting twists, has stimulated us to question our values and the messages that inundate us daily in our contemporary urban landscape.

Les Levine is a mature artist who has earned considerable international recognition and who has significantly influenced many younger artists. The artistic themes of Levine's oeuvre have been the subject of reviews in a number of in-depth survey exhibitions at several major museums that

have explored the current use of words and images from the advertising context within today's "high-art" mode.

The Everson's interest in Les Levine's art goes back many years and has continuously intrigued, I must say, a series of rather brilliant and innovative (albeit peripatetic) Everson curators. In 1977, under video curator Richard Simmons, the Everson presented Levine's exhibit *I Am Not Blind*, an informative environment about unsighted people. The year before, the museum showed his videos *A Picture Is Worth a Thousand Words, STSA Stamp of Approval*, and *Buy This Idea*. In 1980, the Everson acquired the gift of Levine's book *Culture Hero Masterprint*, a 1965 work. Then-Everson-curator John Perreault originally suggested a retrospective of Les Levine's work in 1985, while Dominique Nahas, Perreault's successor, commenced working on this present documentation in 1988. Now, with equal enthusiasm, under curator Peter Doroshenko, the project is seeing fruition. It is hoped the Everson will not only help document this important American artist's work more cogently, but also stimulate more discussion about the significance of art in our present society and weigh its potential for the broadest possible public interaction.

The use of billboards is an important factor in this current presentation in Syracuse, and we are very grateful to the company, Penn Advertising, and especially David Pridgen, its manager in Syracuse, for donating a significant number of billboard spaces in the Central New York area for the purpose of this exhibition. It is just such enlightened cooperation between the corporate and the non-profit sectors that makes this exhibition more than just an exercise in connoisseurship for a few in a gallery. We have instead a truly public, and hard to ignore, event centered on artwork that not only provokes our minds but also our appreciation for the continued role of the assertive contemporary artist in our daily lives. I also wish to thank Les Levine, the quintessential contemporary artist, for his cooperation and, especially, for his extraordinary visual intelligence, which I believe he uses to the public's advantage.

Ronald A. Kuchta, *Director*
Everson Museum of Art

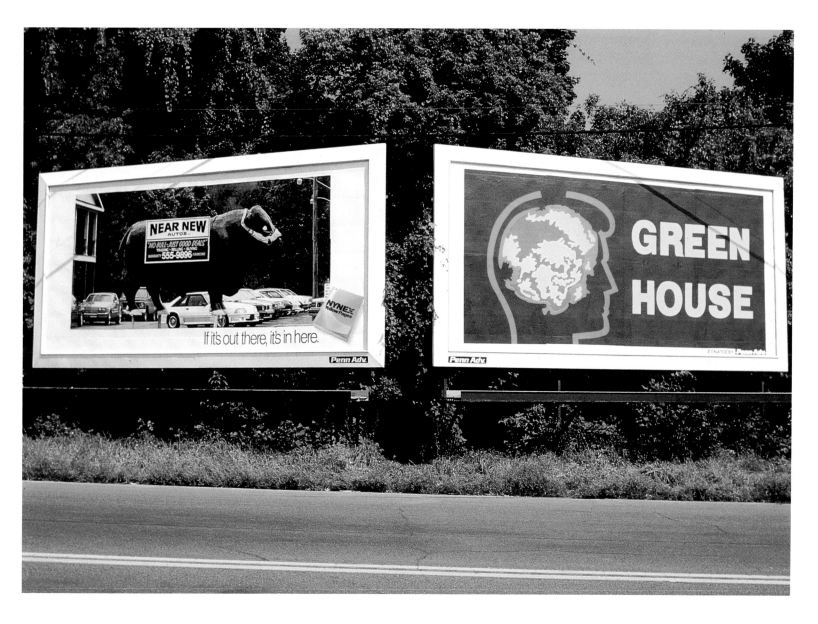

Green House, September 1990. In situ documentary photograph of the Syracuse, New York, billboard project, 120 x 252 in.

A cartoonlike yet intellectually-provocative image towers over downtown Syracuse in a way similar to an all-knowing Orwellian message screen. One realizes that the message the billboard projects is not only informative but also carries an important secret message. It features a simplistic red outline of a human head with a miniaturized earth substituting for the brain; but a gap exists at the top of the head, making the small earth vulnerable. A black ground subliminally transcribes the symbols of outer space as a vast and dangerous atmosphere. Large green block letters spelling *green house* are situated neatly next to the head. They label the image and motivate meaning for and feedback from the viewer. Though one might believe this to be a futuristic public-service announcement, it is the artwork of Les Levine.

Public Mind: Les Levine's Media Sculpture and Mass Ad Campaigns 1969-1990 offers the first comprehensive review of the work of this American artist, who is considered to be the founder of media art. This exhibition brings together more than twenty years of numerous media-inspired works, including large-scale oil stick drawings, actual billboards, subway posters, in-situ watercolors of billboard installations, and computer-scanned laser-jet paintings. From the early narrative videos to outdoor billboards, Levine's interest in public information is to affect every viewer as a consumer—not of objects but of images.

In his working with billboards, Levine, who draws his strengths from commercial marketing and advertising, has been able to elicit a fast response from the viewer. Similar to a television commercial that tells one to buy a product, he concentrates on selling a single idea. In doing so, he combines familiar images (simplified, colorful drawings) and words (direct emotional signifiers), which he abuts into a media friction point. He is thus interested in the barrage of information that is absorbed as one makes contact with the many repeating signs. Since contact with the public is done without invitation on its part, Levine has found a powerful medium that carries the same communicative approaches as does a remote-control television.

As part of this theory, three unique billboards, one entitled *Green House*, the others *Imitate Touch* and *Not Guilty*, are installed in their North American debut at various locations throughout Syracuse. Placed next to conventional advertising spaces, where images of cigarettes, liquor, and popular movie promotions abound, Levine's advertisements are experienced with the same influential impact, generating anxiety with the hope that it will be transformed into desire. Therefore, the billboards are to be treated as off-site artworks that form a complex media and advertising blitz.

This exhibition and catalogue are meant to be thought of as small glimpses into a very complex and extensive exhibition history. Nothing short of a dense, encyclopedia-sized volume could ever contain all of this

artist's detailed endeavors. The lengthy essays and probing interview do cover all of Levine's most important thoughts and works in a straightforward manner.

With certain exceptions, most of the reproductions are organized chronologically so that the works can be assessed year by year. If one views this exhibition of over seventy works and thirty-three billboards, or pages through this anthology of material, a clearer understanding of media-inspired art will be formulated. With so many of today's artists either referring to media in their work or being inspired by its concepts, it is important to evaluate the vast, pioneering achievements of Les Levine, an artist of unquestionable talent, media insight, and material versatility.

Peter Doroshenko, *Curator of Paintings and Sculpture*

Everson Museum of Art

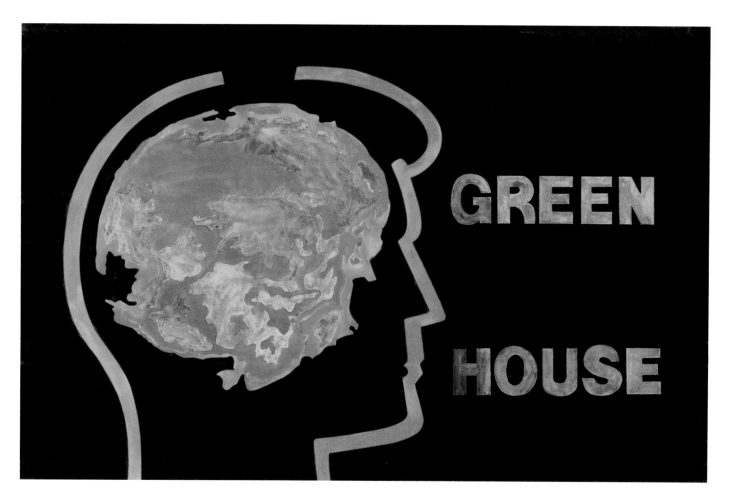

Green House, 1989. Watercolor, 26 x 41 in.

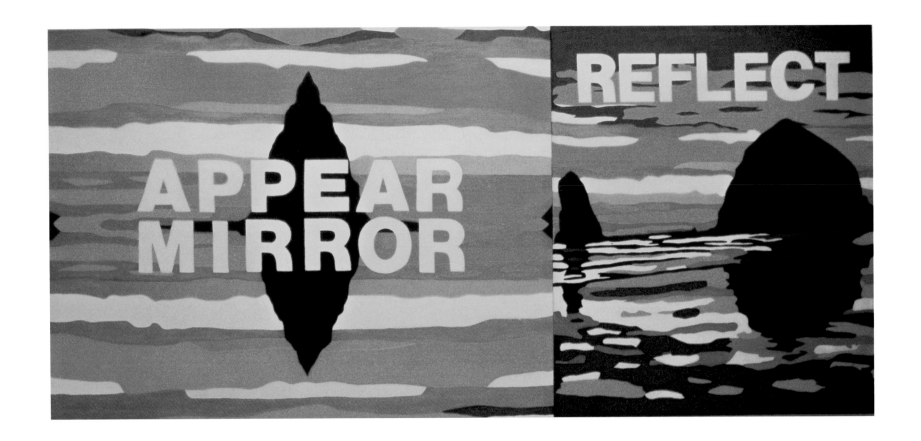

Appear–Mirror–Reflect, 1985.
Acrylic on canvas, 68 x 148 in.

The coalescence of the language of form with words, in all of its manifestations, from classical statuary and monuments and their inscriptions to Renaissance manuscript illuminations, has allowed experiences that have confirmed that descriptive and heuristic sensations derived from words only add to the pleasures of the visual text.

By 1912, with Picasso's inclusion of the first printed "ready made," a newspaper fragment, as part of his first papier collé, the world of modernity entered the world of art. With the title of the futurist manifesto of 1913 by Marinetti (the first mass-media agitator) we get a whiff of the excitement of a new artistic age based on the liberation into chaos, and of the untethered imagination: *Destruction of Syntax–Imagination without Strings–Words in Freedom.* Ambiguity and contradiction in the words and images of the futurists, the dadaists, and the surrealists, and the introduction of the fragments of the real world in cubist space provided artists a new screen on which to project the unrestricted. Simple and direct, words were to hold their own in the world of visuality. They could be representations or abstractions, subjects and objects, simultaneously, as well as esthetic tools and operating procedures.

In the 1960s, and the two decades that followed, artists found ample ways to reinvest with meaning the word and text, and the word as text. Robert Rauschenberg and Jasper Johns revitalized the spirit of Duchamp's linguistic wordplays that had preceded them, and the scale, style, and triteness of words and images of mass advertising were reproduced by the Pop artists without editorial comment. On the West Coast, Ed Ruscha isolated individual words and treated them in representational fashion; and John

Baldessari, with the intervention of a hired sign painter, indulged in self-referential linguistic and photographic horseplay, while seriously questioning accepted pictorial and compositional conventions of "fine-art" image making. Baldessari, with Hanne Darboven, Joseph Kosuth, Lawrence Weiner, and others of the conceptual movement, worked exclusively with ideas and words as they defied and defined the production of art, the art market place, and its parameters. With "systems" or "process art" of the mid-sixties and early seventies, documentary texts, photographs, and diagrams replaced the artworks proper, and language also became the domain of videotape, artists' books, newspapers, and performances.

It is fair to say that Les Levine's wide-ranging works in the mid-sixties through the mid-seventies aroused equal amounts of admiration and antagonism. With his brilliance and his gift for attracting visibility, Levine's astonishingly acute perceptions of technology's impact on social relations and its effect on our ingrained habits of perception were made evident through a stream of works laced with self-knowing and penetrating clarity. One of the leaders of the conceptual movement of the mid-sixties, here was a mild-mannered, thoughtful, soft-spoken provocateur if there ever was one. Levine soon became well recognized for his persistent questioning of the art-world's system of values manages to provoke, infuriate, and entertain critics and broad audiences with an assured wit and sense of the dramatic.

Born in Dublin in 1935 and now living in New York City, Levine has made numerous video tapes since the mid-sixties and has used technology and information media extensively since the late sixties. In 1966 he introduced the term *disposable art*, and he

coined the term *media art* to describe his work in the 1970 *Software Show* at the Jewish Museum. In 1974 he introduced the term *camera art* in a widely reproduced essay originally accompanying the group show of the same name at the Ben Shahn Art Gallery at William Paterson College.

While Levine's first media campaign was realized in 1982 with his *We Are Not Afraid* project, a statement from the *Camera Art* essay eight years earlier makes clear the one important objective that has been the basis for all of his works, particularly the mass-media projects:

> **What good…artists are doing is raising art beyond the level of mere taste…art must be completely devoid of logic. The logic vacuum must be there so that the viewer applies his own logic to it and the work, in fact, makes itself before the viewer's eyes. So that it becomes a direct reflection of the viewer's consciousness, logic, morals, ethics and taste. The work should act as a feedback mechanism to the viewer's own working model of himself.**[1]

Levine's works from the mid-sixties through the early seventies often incorporated new materials and introduced new fabrication techniques (as in *Slipcover* [1966], *Clean Machine* [1968], and *White Sight* [1969]),[2] thereby substituting technology and information media for traditional painting and sculpture. His environmental and process pieces supplanted traditional visual, aesthetic appreciation with physiologically attuned, experimental, and kinesthetic ones. Often, the components in Levine's works were intended to

1 Les Levine, *Camera Art* (Wayne, NJ: Ben Shahn Art Gallery at William Paterson College, 1974), p. 8. A reprint of this article appeared in *Studio International,* July-August 1975, pp. 52-54; and an excerpt from it appeared in Susan Sontag's *On Photography* (New York: Dell Publications, 1977) pp. 193-94.

2 Levine's earliest works in 1964 and 1965 at the David Mirvish Gallery and the Isaacs Gallery in Toronto consisted of silver-sprayed canvases. In 1966 Levine exhibited thousands of vacuum-formed colored and white plastic squares with relief impressions of tools, bottles, plates, fruit bowls, and abstract shapes in his exhibition at the Fischbach Gallery entitled *Disposables*. Selling for between $3 and $6 each, the artist's unlimited, unsigned works raised questions about the value of romanticism in art, the aura of the object, and the distinction between permanence and transience. It was also an

obvious commentary on the marketing and distribution of art based on the scarcity of supply.

The environmental work *Slipcover*, shown at the Art Gallery in Toronto in 1966 and a year later at the Architectural League in New York and the Walker Art Center in Minneapolis, was concerned with the manipulation of sound effects and the displacement of space and included an audio feedback mechanism. The viewer walked into rooms with floor, ceiling, and walls covered with billowing mylar polyester film loosely mounted on wooden frames with electric blowers mounted behind them. Delayed playback voice recordings of the audience's comments, changing light patterns, and the sound of air compressors complemented the visual effects.

The *Clean Machine* (1968) was an early environmental piece composed of sixty six-foot-high white plastic modules arranged to form a passageway around the perimeter of the Fischbach Gallery. Levine's press release stated, "Because of the deliberate elimination of visual distractions it will be possible to experience the direct sensory relationship between yourself and objects."

Levine's *Star Machine*, a walk-through unit made of free-blown plexiglass, was meant to alter spatial relationships; as was *White Sight (1969)*, an environmental work using monochromatic sodium vapor lights and chrome-plated pressure-sensitive mylar.

White Sight, along with *Wire Tap, John and Mimi's Book of Love, Fecaloids, Monuments, Nebulizers, Thermotaxis, Topesthesia,* and *Signature Print-Outs,* was grouped in Levine's *Body Control Systems* exhibition at Isaacs Gallery. In this remarkable array of work, the artist displayed an acute grasp of the epistemological implications of new technology. Concerned with what he termed "body ecology," the artist, the public was informed in a press release, presents the body as a universal technological and ecological system. "Man," states Levine in the release, "has entered a state of post consciousness ...we are extensions of a main circuit...real systems, body technology and ecological conditions control our cultural thrust rather than any previous idea of consciousness we may have had." The works in the *Body Control Systems* exhibition dealt with the role of privacy in the age of information, the recycling of materials to create artworks, the questioning of the concept of monuments in contemporary society, the control of atmospheric conditions and air quality, and the possibility of regulating the mechanisms of physical sensations through artificial devices.

explore the behavioral capacities and characteristics of the viewer. In order to do this, Levine's environmental situations often included feedback devices (videotapes and audiotapes), which heightened the audience understanding that it was the subject of the artwork and that the process of experiencing the situations they found themselves in was the end of the artist's efforts.

Finally, many of Levine's early "systemic" and "real time" works (*Body Control Systems* [1970], *System Burn-Off x Residual Software* [1969], *Levine's Restaurant* [1969], and *Culture Hero* magazine [1969]) questioned the mechanisms of the art world as a self-regulating organism whose social parameters and monetary substructures were based on the concepts of quality, originality and uniqueness, and taste. As Levine's works pointed to art as reified social context (whose finished state took form, according to Levine, as information), the role of media as a mechanism in the appraisal, promotion, and codification of art became of increasing interest to him.

In the early seventies, Levine began to combine images and text in order to make more explicit social or political commentary. *The Troubles: An Artist's Document of Ulster*, shown at Finch College in 1973, was Levine's first political *media sculpture*. This term was first applied by the artist to *Systems Burn-Off x Residual Software,* Levine's sardonic exhibition of anti-art and disposable art based on the anti-art Cornell *Earth Art Show* of 1969. Levine's exhibition included thousands of copies of photographs he had taken of critics who had been flown in to review the show.

The Troubles was an installation with barbed wire that included his slides, interviews, film, photos, and photo etchings as well as art made by prisoners in internment

camps, and recordings of folk songs and noise used in torture. Levine functioned very much as a reporter on the front describing the bitterness felt by Catholics and Protestants because of the devastation in Northern Ireland. In the 1973 *Saturday Review* article "It's Realistic But Is It Art?" he writes:

> **I have for many years concerned myself with the systems of art as they relate to society in general, that is to say with the sociological value of art and art's real service to society. Media are my materials. I am interested in using media to effect change and understanding of our environment. I want to consider media as a natural resource and to mold media the way others would mold matter. In that sense my new work could be considered media sculpture. I was forced to ask myself, Are the social and political problems of a society a valid concern for art? The answer was "Yes, of course..."** [3]

3 Les Levine, "It's Realistic But Is It Art?" *Saturday Review*, February 1973, p. 18.

Throughout the mid-seventies, while continuing to produce an astonishing number and variety of videotape works, Levine pursued his interest in the role mass media plays in forming our (mis)perceptions regarding social and political realities. In a number of exhibitions and pieces, only a few of which can be mentioned here, Levine widened his range of media and materials to communicate his concerns more effectively.

The Last Book of Life (1974) was a text, neon, and photo work focusing on an image of Nixon in the company of Chinese officials at a dinner. The piece analyzes the

position of the various raised chopsticks and their possible significations for a new US

political course in China. In 1976, *Disposable Moment*, a commercial by Levine, was aired

on ABC Network in Australia. In 1976-78 the installation *Game Room* included pinball

machines and a band of message readers around the perimeter of the gallery, with mes-

sages related to the theme of the show (which concerned the idea of winning and losing in

the American political and educational system). In the same year *What Can the American*

Government Do For You?, an installation at the M.L. D'Arc Gallery, included a videotape in

which seventy-six people, in various locations in the United States, responded to this

question. The *Soho Poster Project*, a visually unrelated poster announcing the exhibition

and Levine's first attempt at street art, was judged a failure. These striking posters,

plastered in downtown New York, consisted of a headshot of the artist staring directly at

the viewer. The eyes of the artist had been airbrushed to make him appear to be an

Oriental. Levine considered his surreptitious activity of plastering posters as "vandalistic"

and too confusing in terms of intention.

　　　　　With his *Photo-Ads* series (1974-77), multiple image photographic works; his

Ads series (1974-80), enormous color photos and giant painted words; and his *Country Bill-*

boards series (1979-80); Levine kept modifying the highly formalized combinations of words

and images that were to be the basic structure of his mass media works in the eighties. All

three series were meant to subvert the traditional commercial aims of advertisement by

adopting familiar ad formats; all of the work were designed to be modified or translated for

billboard and mass media use, and Levine incorporated many of the images in in-situ draw-

ings as proposals for public spaces. The *Ads* and *Country Billboards,* particularly, were powerful, synthetic pieces. They show the evolution of Levine's increasingly compact conflation of words and images. Levine, in envisioning these works placed in public contexts, intended them to mimic advertisements. Without the "hook" of straight ads, however, he saw them advertising their own contents rather than selling products.

Levine's complex and resonant system of word-image interrelationships allowed him to engage in witty, thoughtful, and at times poignant commentary on the art world and on social or philosophical issues without sentimental rhetoric. In the *Ad* entitled *Pink Unconscious*, for example, in which four women in pink and white uniforms are shown working in a bakery, the artist, while referring to Jackson Pollock's painting *Blue Unconscious*, makes complex allusions to the ideology of formalist painting and its role in supporting gender bias in the art world.

In another *Ad*, the 1975 four-panel *Tired Earth*, the impact of the photo work's suggestive force depends on the tight visual correlation made between the two-tiered mental construct: the verb *tired*, next to a photo of a rutted field, and the associations that can be inferred between a state of exhaustion (the understanding of the word as an intransitive verb) and a land subjected to the pounding of tractor tires (the punning use of the word *tired* as an adjective) combined with inferences formed by seeing the word *earth* next to the image of vulnerable land, a strip mine, placidly awaiting further injury.

In *A Boy Making Sculpture*, a 1980 *Ad*, large yellow block letters of the title are situated above the pairing of four photographs. These are sequence shots of a youth

on a park bench feeding pigeons by placing bread crumbs first on the ground, then on his body. Levine has left the image-text sufficiently open to warrant several interpretations. Those might include the following three: an allusion to body art, a self-referential indication of the artist who has created a (media) sculpture, and, in pointing out an example where animate nature acts upon inanimate man (the boy is being treated by the birds as any traditional sculpture, as a landing pad), perhaps the artist is suggesting we reprioritize the traditional roles assigned to nature and culture and that we reaccess their functions in our lives.

The *Country Billboard* series, made at the end of the seventies, is the result of Levine's search for alternatives to the straight photographic work he had been employing up to this time. The "billboards," large oilstick on canvas works, were based on photographs. They have a constructed quality intended to visually redefine the works as flat, literal objects and to eliminate illusionistic space as much as possible. The literalness of *Taste Class* (1980), for example, is stressed by emphasizing the support structures. In this cruciform-shaped work, separate panels of each of the words frame the images on the two stacked central panels—simplified, hand-drawn images of earth-moving and sugar-cane-harvesting machines. The mental associations in this work are activated if the word *taste* is understood as a modifier of the word *class*, forming a new category in the social order, *tasteclass* (as in *upperclass).*

In the *Country Billboard* titled *Taking a Position* (1979), literalness is emphasized by the flipping of the central panel, thereby inverting the words and making a reference to Jackson Pollock's head-body position when making art. On a broader level,

Levine suggests that taking a stand on things might lead to ultimate defeat: the central panel is flanked by the twice repeated image of a dead deer along a highway.

Les Levine's first outdoor billboard campaign, *Aim, Race, Take, Steal, Forget,* occurred in Los Angeles and Minneapolis in 1982-83, following the success of his first subway mass media project, *We Are Not Afraid,* in New York City in early 1982. The campaign in Los Angeles consisted of ten of the billboards arranged sequentially along a major highway, while the Minneapolis campaign involved twenty-five billboards placed randomly in the city. The campaign's imperative verbs, *aim, race, take, steal, forget,* and their corollary images, a deer, horse, mechanical crane, building, herd of elephants (listed respectively), constituted Levine's first public usage of a format that broke down the representational component of each billboard into simple, flat, colorful shapes designed to be easily recognizable at a distance. It was also the first time (and would be the only time) that a quasi-narrative element appears in Levine's mass media billboard works. This narrative, an explicit mental strategy, or the suggested unfolding of a course of dishonorable intention, adds a pungency to this particular work that would only be rivaled in 1985 with Levine's *Media Mass,* the Spectacolor lightboard project. (In *Media Mass* the words *cheat, hate, kill, lie, race, rape, sell, starve, steal, win* flashed for thirty seconds every ten minutes amidst regularly programmed commercial advertisements. The artwork seemed to imply that the regular commercials promoted the negative behavioral patterns suggested by the artist.)

The Los Angeles-Minneapolis campaign proved that Levine's images

worked equally well, if differently, when grouped together, stood alone, or dispersed among regular advertisements. In the latter case, each work's context generated additional associational information in the viewer's mind. If the billboards were isolated, the image-text of each specific piece was sufficiently densely devised to elicit a flurry of internal meanings based on the rebus (race-horse), the pun (steal-steel), folkloric associations (elephants-forget), or mental associations of nature being acted upon by man (deer-aim, earth-machine).

Aim, Race, Take, Steal, Forget meets all the requirements for the subsequent billboard campaigns in the eighties: an assured directness and simplicity in the way the images are drawn and a deceptively simple grouping of words that allows the viewer to construct a series of possible meanings that are personally relevant or significant. In April 1990, Levine made these comments on art that are relevant to his own way of working:

> **A work of art is a metaphor for the world, for the way the world can be seen, for how you find yourself in it and what you can do in a relationship to it. But more than anything else a work of art is permission to be what you see. To participate in the vision that is presented...[art] gives the impression that life is worth living. Of course it implies what kind of life is worth living because art is a particular thing. What is good about good art is its particularity, its specificity; a good work of art is a compendium of specifics. It keeps telling you where you should be going, it keeps telling you in what direction you should be**

looking, in which areas you should not be looking and what

attitude you should be avoiding. It is respecifying the conditions

all the time if it's a good work.[4]

4 Les Levine, interview with Marja Bosma in "A Space
 with a Language to Exist In," *Analyze Lovers*
 (Utrecht: Centraal Museum [Utrecht] Emickery
 [Amsterdam], 1990), p. 6.

Dominique Nahas, *Guest Curator*

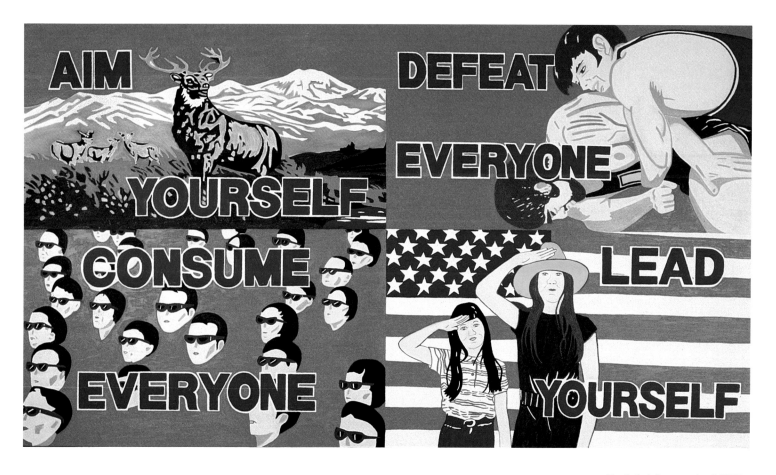

Aim, Defeat, Consume, Lead, 1987.
Oil stick on canvas, 68 x 114½ in.

Les Levine has made a singular and significant contribution to the development of late twentieth century American art. His accomplishments, in light of his mass media works over the past decade, have been remarkable for two reasons. First, in spite of the inherent sensationalistic aspects of the billboard medium and the necessity for the artist to efface any unnecessary personal mannerisms that might intrude on the manifestation of communicating fully with what Levine has called *public mind*, what has emerged out of the artist's efforts has been a profoundly compassionate and evocative view of the world; so much so, it is not unlikely that the power of outer-directed media used in the hands of inner-motivated artists like Levine might revitalize the power of art-making in the future and make it truly activist in spirit.[1] Secondly, Levine's art, it must be kept in mind, is surely provocative on many levels (linguistically, conceptually, philosophically, politically, formally), and it is doubly so because it *is* media: it doesn't only use media concepts, it doesn't merely refer to media nor is it only influenced by media. The premise, and importance, of Levine's work is that it is an aspect of media itself.

Imitate Touch, one of Levine's latest billboard images, could be considered a summation of the artist's thoughts on media. Containing a simple and direct image, this billboard is contrived for immediate readability, and it is the result of a careful and systematic search for the right word, image, and color combination that will outperform on the level of accessibility in the competitive, over-saturated environment of billboard advertising.

Like a man wearing a red hat in a crowded room, *Imitate Touch* is hard to beat in its attention-grabbing capacity: a high-pitched red background, large block letters at

1 Levine's art is an art of resistance because it unveils stereotypes without substituting new ones to take their place. Levine's art is art with a politic, not political art. It is concerned, to use Hal Foster's words, "with the structural positioning of thought and the material effectivity of practice within the social totality, [and] seeks to produce a concept of the political relevant to our present." From *Recodings: Art, Spectacle, Cultural Politics* (Seattle: Bay Press, 1985), p. 155.

the top (IMITATE) and bottom edge (TOUCH) of the billboard frame. The Michelangelesque

outlines of a left and right forearm and hand, index fingers outstretched, are about to meet

along a white zigzagging lightning bolt (the media-ized updating of the actual break in the

surface of the Sistine Chapel ceiling). This lightning bolt, which begins at the middle of the

top edge of the image, grazes the left angle of *a* and careens downward, ending its trajec-

tory slightly to the left of center of the bottom edge of the image after having zigzagged

between the letters *o* and *u* of *Touch*.

Levine's use of the bolt splits the image into two parts and accentuates

the attempted reconciliation between two forces whose index fingers are poised to meet.

The artist's use of a two-word phrase in his work (referred to by Levine as "two-word

time locks") consists frequently of an imperative verb and a noun or modifier, both

set off against a simplified drawing originating from a photograph taken by the artist.

This combination of word and image sends off patterns of possible open-ended

interpretations to the viewer. These are the result of mental associations emanating from

each word's lexical meanings and from the ideational correspondences that are set

into motion from the semantic constructions possible between sets of words, as well

as from the interplay between these bundles of associations and those derived from

the visual image provided. The net of associations becomes commensurably denser

as Levine's billboards are introduced, unannounced and unsigned, in the public

sector next to and amidst billboards promoting consumer goods, often cigarettes

or alcohol.

Dominique Nahas: What do the words in your work mean?

Les Levine: The words that are used in my work are already laden with baggage, with rhetorical linguistic attitudes. They already say this or that in a very general way. What's so wonderful about the billboard *Switch Position* is that you have a frog which is a thing that jumps in a kinetic way and then you're being told to switch position so that as you're looking at it you're being told to have another point of view. You're being told, "Whatever you're thinking now, you should think something else." So that's what I mean by meaning. What does that mean? It doesn't mean anything definable. It's very abstract even though the image and the words are not abstract. It leads you into an abstract sensation of thought, because it denies you what you think should be a logical conclusion and a defined answer. It could mean, "Have a different attitude," or change anything that

In light of the fact that Levine's works entail not only an understanding of flat surfaces but also an understanding of spatial surroundings of public (often urban) environments, his works are properly considered *media sculpture*, a term the artist publicly defined in 1973.[2]

Imitate Touch conveys Levine's thoughts on the role and aim of mass media: to double the sensate experience. He explains:

> **My whole concept of using the creation of man segment as the concept of *Imitate Touch* is two things: One, *Imitate Touch* is not a complete sentence, but you think, now that you've heard it, it's always been there. Two, I'm thoroughly convinced that the Renaissance view of touch is not that far off. That the implication that things are created by being touched, that touch is the moment after the creative impulse which actually makes the thing…In the long run touch is the act of creation… Just the creation that creativity is touch and touch is creativity. And touch without creativity is like rape or insensitivity or something that's ugly or impractical. The ultimate desire of media is to imitate touch. That is its ultimate desire. It is to replace the concept of passion and desire with the concept of surrogate touch. Ultimately the meaning of media is…to eliminate the notion of body.[3]**

2 Les Levine, "It's Realistic But Is It Art?" *Saturday Review*, February 1973, p. 18.

3 Les Levine, interview with author, November 17, 1989. Levine has written: "We have a situation now where the body cannot live off its own support system. Being a conscious containing device and a biological entity, it wants to continue. It wants to devise mechanisms for its survival. And so it devised a system capable of housing all the information previously housed in the human body…It now seems that what we are in human life has come to a point where we can't work out the problem of how to continue. So a certain part of our natural animal instinct has attempted to devise another means of survival. It's amazing how much media is based on the behavior of certain parts of the body. We can't continue, but we want to continue. So we say, we can't interact at a body level anymore because we realize that a greater more efficient communication occurs at a mind to mind level. Once the objectness of anything is removed the information gets more expressly to its point. It is the body that actually interrupts the flow of information." From *MEDIA: The Bio-Tech Rehearsal for Leaving the Body* (Alberta: Alberta College of Art Gallery, 1979), p. 12.

As an artist working within the landscape and mindscape of mass media, Levine's work suggests an acute understanding of how, why, and what kind of information is sent and received through these means. As Levine's efforts are involved with the generation of information into the mainstream, his works, often considered aggressive due to their provocative nature, are the result of a long-term investigation of the nature of public mind and how to address this mind as effectively as possible. The artist has attempted to use conventional commercial media strategies, devices endemic to mass advertising, such as incessant repetition and interpellation of the individual as the assumed spectator, the imaginary subject addressed by the ad.

I want to advertise because it's the only way I can connect with how lonely people feel in public. My work is specifically for the public. It is a direct dialog with the public on issues that are of some concern to them. The public must assume in looking at public art "that's for me...that has to do with my life." In looking at public art the public should feel a familiarity with their inner self. The presence of the artist as physical fact should not be felt by the public. They should feel, however, the presence of ideas which they feel are projections of their own experiences.[4]

Levine's mass media campaigns are contrived to trigger emotional responses, to heat up the coolness of media, and, simultaneously, to create a particular effect that is conducive to deep communication. The kindling of anxiety plays an important

happens to be in your mind at that instant. It's not what a set of words means when they're initially spoken, but how a set of words *move through time.*

What was fascinating with the piece *Race* was that no matter how many times you said *race*, and no matter how many times you thought of it as being a race horse, race, a foot race, a rat race, no matter what you tried to do with it, it couldn't evolve into anything other than *race*. In a piece like *Switch Position*, you keep going through these layers, into more layers, and you finally find yourself coming back to the fact that it is what it says—that whatever trick you thought existed here, doesn't. The main point is that that is the information. "Switch position" is the point. When people look at something they're inclined to say, "Ah, that means that. But, no, it must mean something else." It

4 Les Levine, interview with author, October 10, 1989.

role in Levine's work, as it does in all advertising. This anxiety is used by commercial media to promote desire, hence sale, through structural mechanisms that emphasize the individualism of its subjects while paradoxically and deliberately feeding off the subject's need for self-meaning and coherence. Desire is then routed through an exchange of meaning in ads in which people intimately redefine themselves through product identification.

Les Levine's billboard campaigns, although each quite diverse in style and content, stimulate that state of intimacy in a public experience that is based on a passive sense of anxiety on the part of the viewer. This anxiousness, as the artist has defined it, is not to be understood in the pathological sense, but is a residue of a heightened level of awareness that normally makes itself felt in public spaces. In this emotional condition, in the public arena where alienation and the need for community coalesce, it is possible, according to the artist, for the most vital information to be received. Anxiety, then, already a precondition for the effectiveness of the structuring of advertisements in mass media, is, in the context of Levine's publically situated media sculpture, displaced and transmuted into a dynamic positive force. The billboards become, as the artist has stated, "props" that aid the public in understanding their own value systems. This experience, although a public one, gets to the depth of private feelings and, through the billboard media, is intended to generate for the public a vision of their own uniqueness; "a uniqueness," the artist says, "which they always had before my work."[5]

One of Levine's primary intentions with his billboard campaigns is to make contact with the uninitiated public without asking for its approval. This intention, already

5 Idem, February 28, 1989.

much in evidence as early as 1969 in *Levine's Restaurant* (what Jack Burnham categorized as the "ultimate real-time art work"[6]) and in the same year in *Contact: A Cybernetic Sculpture* (commissioned by Gulf & Western for its headquarters), gives the artist's media campaigns their sub-propagandistic undertones.[7] Levine's objective, an unannounced exchange with the public on issues that are of concern to him, results in the blurring of the parameters that separate art and advertising. This ambiguity, derived from the artist's manipulation of cultural signs, social contexts, visual conventions, and communication systems, has given the mass media campaigns their impact and has been the source of their importance.

In planning his giant blowups-and-word-combinations for the campaigns, Levine has resisted thinking of each urban site or referring to each particular city in specific geopolitical or historical terms. Instead he regards each new venue as a carrier for a point of view, a state of mind, or a particular psychological attitude that he has determined needs to be expressed at that particular point in time and space.

The Dortmund billboard project of 1989, for example, was initiated to express the worldwide concerns over the degeneration of the environment and the nuclear arms buildup. In the former case, Levine's billboard image depicted a red-outlined profile of a man's head on a black background. A conspicuous gap appears at the top of the head as a schematized image of the planet earth hovers within the head's outline. The large green block letters forming the words *Green House* are positioned to the right of the profile, across from the areas of the eyes and mouth. The viewer, through a process of visual

would be so terrific if things just meant that. It would be so wonderful if when you look at something it simply means what it seems to mean; because that's so much a part of our present existence. It's so opposite from the kind of modernist and pre-modernist existence where everyone was so involved with this kind of esoteric individualism, where the concept was that if anything means anything clearly (to me) it exposes too much of what I might want to hide. So people took clear meaning in those periods of time as personal mind exposure, which changes under the onslaught of information. You're not being asked to consider the meaning once a week; you're asked to consider meaning once a second because of the amount of information coming to you. Then all of these psychologically personal connections that you have are apt to fall away, because they're slowing the mechanisms. What they tend to do is to make you personalize

6 Jack Burnham, "Systems Esthetics," *Artforum*, September 1968, pp. 30-35.

7 Jacques Ellul makes a distinction between political and sociological propaganda. The latter, he categorizes as sub-propaganda. "Sociological propaganda is a phenomenon…more difficult to grasp than political propaganda. Basically it is the penetration of an ideology by means of its sociological context…The existing economic, political and sociological factors progressively allow an ideology to penetrate individuals or masses…At this level, advertising the spreading of a certain style of life can be said to be included in such propaganda." From *Propaganda, The Formation of Men's Attitude* (New York: Vintage Press, 1973), p. 63.

metonymy, is invited to make associations between the seriousness of having a hole in the ozone layer and that of having a hole in one's head deep enough to expose the brain. The two words increase the level of possible correlations that lead, as the artist has pointed out, not to free association but to more directed, restricted levels of interpretation.[8]

Levine's use of a radically flattened and simplified image of Michaelangelo's *David* (in two pieces) against a red background with blue letters forming the words *Consume Or Perish* above the image and, in *Pray For More*, the joining of these words with the schematized image of two hands holding a praying mantis (an oblique reference to Michaelangelo's *Pieta*) in Levine's *Consume Or Perish* campaigns in Dijon and Stuttgart in 1988-89[9] and in his *Pray For More* and *Consume Or Perish* New York subway project of 1989, were meant to raise questions about the central mode of interaction in Western societies and the increased tendencies toward a radical commodification of art.

The New York subway project's two different artworks were placed in 4800 of the premium squares advertising spaces (those with the greatest visibility, at both ends of each car) in the IRT, BMT, and IND lines. This project allowed Levine to experiment with dense visual cross-referencing; the subway project implied a spatial structure between both ads to the public, apart from each ad's own information. This project also allowed the public close inspection of Levine's high-contrast style, with its use of flat blocks of silk-screened color indicating volume and form. This style emerged between 1980 and 1982, after the artist's experimentations with color Plasticine which he laid out in flat shapes over window screens. Levine used this technique in order to force himself to reconsider his

8 "Being neither work nor image the words are defined pictorially and the pictures are defined verbally. In that sense their context is immunized against free associations. They are definite. However, their definitions are resolved by what the viewer brings to them." Les Levine, interview with Ted Greenwald, from *Les Levine: Media Projects and Public Advertisements* (Lucerne: Mai 36 Galerie, 1988), p. 13.

9 The Dijon and Stuttgart campaigns also included the work *Feed Greed*.

earlier, and successful, use of photographic images and words, most notably in his *We Are Not Afraid* (1982) project:

Art never stays the same. It gets weaker. By the time I had finished doing *We Are Not Afraid* it was the culmination of work I had done using images and photographs. By the time this subway project was over, photographs and texts had become a very belabored style. Everybody with press type and a camera was doing it. I was getting little pleasure out of saying to people who saw my work in a lot of galleries, "Well, that isn't my work." I wanted, after *We Are Not Afraid*, to try and reinvent my way of looking at images. I wanted to have a flat simple advertising style. And I think the later work is like that. I also recognized one thing: that when you go into a public environment, a subway, a street, whatever…everything looks photographic. A person walking down the street looks like a person walking down the street as in a photo. A car on a side of street looks like a car in a photograph of a car on the side of a street. I decided I should do something that doesn't look like a photograph. To try and go around this sort of half-grey environment that seems to exist in all cities. One of the things that interested me was how could you bring giant blocks of color in amongst all this. I found that

the event and make it impossible for you to act. So the more we get into information processing, the more we have to disconnect it from our personal psychology. The fact that you can immediately respond to something is not the personal psychological exposure it was fifteen years ago. The fact that one looks at something and sees what it is, is very much a concept of the younger generations. They are responding even faster to symbols that are presented to them. If you put letters or numbers in front of young kids, they'll immediately organize the letters or numbers and tell you what the point of the numbers is. They do that because they watch more television. They have more access to information at an earlier age than any of us ever did. So they're getting much earlier training in responding to information. Their psychology is organized and architectured around considering information; as opposed to ours, which is organized around the idea that all information coming in is acting in some way

10 Les Levine, talk given at the State University of
 New York at Purchase as part of the Visiting Artists
 Series, February 13, 1990.

the billboards around my billboards don't have that strength of force. They've become so familiar you simply don't see them. I wanted to invent a way to get higher vision, more immediate vision. To stand out against all this background.[10]

The *We Are Not Afraid* New York City subway project of 1982 was Levine's first realized mass media project and the first to be done anywhere in the world. Over 4000 of his placards were put up in all the major lines. They caused a sensation. The concept and design for this enigmatic and highly successful work had been completed by the end of 1979 and had already been shown in various exhibitions in Europe in the following year as well as in the United States in the subsequent two years, notably in the 1981 exhibition *Pictures and Promises*: *A Display of Advertising, Slogans and Interventions*, curated by Barbara Kruger for the Kitchen Center for Video and Music.

The photograph, taken by Levine, that was used in the *We Are Not Afraid* project was that of a casually dressed Oriental couple standing against a purple, dusk sky. The man looks beyond the camera, out of the frame of the picture, and the woman looks at the viewer. Two-inch red letters forming the words *We Are Not Afraid* appear above the heads of the couple and complete the image. Placards with this image were situated in the cars of all the major subway lines and they elicited immediate responses from the public. The image-text seemed to infer a resolution toward, if not of, the general fear of urban violence; yet, it suggested nothing specific to the straphanger to whom it was directing its attention. What was clear was that the slogan implied another clause without

supplying it, and the image of the tranquil, impassive Orientals, placed in the public context of a city filled with black-white disharmony, suggested racial neutrality as well as serenity and wisdom. The work seemed to sum up a variety of urban concerns and hopes.

In examining *We Are Not Afraid* we can see how carefully the artist worked within the conventions of mass media in order to achieve maximum effect. While he realized his message had to be bold and simple, he was also aware that he had to modulate his choices of words, word structure, and the contents within the photograph in order for the public to serve as a vacant vessel broad enough to pour its own meaning into it. With this in mind, the artist also realized that the image-text had to be sufficiently loaded with meaning in and of itself, generically, in order for it to trigger and generate a continuing flow of associations. This flow, in turn, would allow the viewer (in the artist's words) "to take [it] to the level of emotional episodes...In order for this to happen the episodic relationship between word and image—that clash between both—is important."[11]

In several past billboard campaigns (the *Blame God* media campaign of 1985-86, the Documenta 8 *Forgive Yourself* project of 1987, and the *Brand New* project of 1989 in Frankfurt) Levine appears to have heightened the level of these by allowing social or historical subtexts to seep through the image-texts in varying degrees.

In the *Brand New* project, vivacious cartoon images of a pig, a frog, a mouse, and a rooster (animals that appeared previously in Levine's 1978 exhibition *House of Gloves*) are respectively conjoined with the words *Get More, Switch Position, Draw Charm,* and *Brand New*. The artist has not intended for these three-by-four meter billboards

against the possessive notion of self. So our information looks at any information coming in, or any information we let out, as a modification of our self-view.

DN Are you saying that the younger generation is in possession of a dispossessed self?

LL More so than we are.

DN What are the ramifications?

LL They are not probably as connected as we are.

DN But that's only from our perspective.

LL Yes, in some way they're more connected; they can move quicker than we ever could.

DN And there's more fluidity...

LL Yes, they're less likely to be involved in aspects of desire that make strong demands on them. The whole notion of getting more information all the time is the rejection of desire. In some way

11 Les Levine, interview with author, March 22, 1990.

to be viewed art-historically, nor were they devised to bear academic analysis. Their juxtaposition amidst commercial advertising on the street produced a variety of mental connections. Acting as advertisements (for themselves) when standing alone, these works were striking as commands; when placed in other contexts they acted as modifications of (other) commands from neighboring advertisements. For instance, the conflation of the image of the perky frog and the words *Switch Position* adjacent to a Winston cigarette ad or a Romer Pils beer ad insinuated an alternative action to that of smoking or drinking. More and different time-place connections based on art-world associations stemming from an ongoing Frankfurt Art Fair could have been inferred were the viewers to have started with the premise that the pig might represent the Collector; the frog, the Critic; the mouse, the Artist; and the rooster, a stand-in for the Dealer—all playing their prescribed roles in the art market.

The 1987 *Forgive Yourself* billboard campaign in Kassel for Documenta 8 included installations in fifty different public places. In these works the immutable second word in a two-word construction is the reflective pronoun *yourself*, which is modified by twelve imperative verb forms: *forgive, consume, lead, seduce, sell, charm, exploit, master, create, hate, free, starve*. Each work includes a simplified image taken from color oil stick drawings made by Levine, which were derived from photographs taken by him or from press and fashion photography.

The messages on the billboards, while intended to be read metaphorically (as are all of Levine's media works) by audiences of all nationalities, alluded to the

German experience to initiate introspection on the part of the viewer. The "hailing effect" of the billboards, derived from a commonly applied commerical advertising technique of inducing the consumer to consider the product or service rendered as a reward or solution to his or her deserved needs ("Treat yourself to a trip to San Juan. Fly...") allowed Levine to produce an exercise in self-examination on the issues and questions of public and private identity and beliefs. German national identity and the burdens of its psychological history after World War II are addressed in several of the works, but only two billboards contain visual references to the Holocaust: the image of concentration camp prisoners behind barbed wire, taken from Margaret Bourke White's photograph of the liberation of Buchenwald, in the billboard *Free Yourself*; and the simplified image of Anne Frank in *Forgive Yourself*. Some of the billboards effectively use Germanic cultural stereotypes as if to reinitiate nationalistic self-inquiry (as in *Master Yourself*, *Create Yourself*, *Lead Yourself*). Others generate response by indulging the viewer with emotional clichés on the expected self-abnegating behavior of the new generation of Germans, as in *Starve Yourself*, *Hate Yourself*, *Forgive Yourself*.

In the *Forgive Yourself* project Levine wants us to ponder the question, What is left of the notion of the self, devoid of body, as it has dissolved in the fluidity of sign systems of mass media and telecommunications? While Levine might agree with Baudrillard's assessment:

The decisive changes in objects and the modern environment, arise from a drift toward formal operational abstraction of ele-

psychologically, desire is more connected to the notion of self, feeling one's sense of self. The more information you have, the more disconnected you might be from those things you might desire. If you want to be extremely theoretical about it, you can say that it's very likely that as people get more and more used to more and more information, and as they get to processing it much faster, they will divorce more quickly. This is because decisions are made on another type of symbology, not on specific connections.

If you look at the young, the personal connections they make are lighter, far less deep, than the type of relationship connections that are made by older people, where there's a lot of sentimentality involved and a lot of symbiotic connections. Younger people don't seem to make that kind of symbiosis. It doesn't

ments and functions, toward their homogenization in a single virtual process, toward the displacement of gestures, bodies, affects in electric and electronic control, toward the miniaturization in time and space of processes whose real scene is that of infinitesimal memory and the microprocessor...Today there is no longer transcendence, but the immanent surface of the development of operations, smooth surface, operational of communication. The Faustian, Promethean period of production and consumption yields to the Protean era of networks, to the narcissistic, equally Protean form of branching, contact,contiquity, feedback and generalized interface. As with television, the entire surrounding world, and our own body, becomes a control screen.[12]

12 Jean Baudrillard, *Fatal Strategies* (New York: Semiotexte, 1990), p. 66.

The artist sees possibilities for a reinvigorated future through self-reflection:

One has to forgive oneself artistically. And historically as no one else has a larger stake in it. I wanted to do something positive. That could make the audience see that their dualistic negativism could be turned on them. No matter how risky, each of us has to take the first step. We truly have to be willing to die for what we believe in. That may mean giving up our mental body so that something new mentally can occur. By giving up our body I mean the body of our history and our attachment.

[Forgive] Yourself definitely follows [Blame] God. After all, once one has killed god there is no one to forgive you except yourself. It could be seen that the two works are part of a media theological trilogy in which the artist is trying to investigate the relationship of mass media to our spiritual understanding of this moment. More simply put, given what mass media has made us believe, what do we really believe in?[13]

The *Blame God* billboard campaign, Levine's most searing and controversial work, was first shown in London in 1985. The campaign was subsequently mounted in Londonderry, Northern Ireland, and, the following year, in Dublin, Ireland.

In this campaign, twenty-one different images were produced and forty billboards were posted in London. The subject matter, the "religious wars" in Northern Ireland, had been investigated by Levine (an Irish exile) twelve years earlier in *The Troubles: An Artist's Document of Ulster*. In that previous work, mounted in a contained exhibition space, Levine showed explicit materials that documented the horrid daily turmoil the unrest was causing the Catholics and the Protestants. This time around Levine would have the opportunity to bring his art directly to the embattled sites, and his method of soliciting critical inquiry and deep reflection had greatly sharpened over the ensuing years.

The twenty-one works contained two words each; the second word remained the same: *god*. The first word in each situation (with the exception of the word *slum*) was an imperative form of a verb. The changing first words on the billboards were:

mean they're wholly disconnected, it means that as they have more access to information and because they are quicker at learning, having begun at an earlier age, the way they process it is entirely different. They take it much less personally. It's something to be seen, understood, responded to, and gone on from. Older people tend to look at things—say a work of art—as a very personal thing. They get offended very easily if they don't like it, where a younger person would say, "That's nutty," or, "I don't like it." They don't think this is a personal attack on them.

DN It's more on the surface...

LL It's the difference between responding to everything in the possessive and responding to everything from an intimate informational level. The escalation of information, by nature, eliminates the possibility for individual possessiveness about the information.

13 *Les Levine: Media Projects and Public Advertisements* (Lucerne: Mai 36 Galerie, 1988), p. 10.

sell, lose, starve, attack, torture, blast, fight, block, forgive, execute, hate, kill, bury, defeat, slum, bomb, create, protect, play, parade and *control.* The word *slum* was used as an adjective (*slum* god as in *slum*lord).

Each billboard contained a color-filled image derived from photographs that Levine had taken in Northern Ireland. Each work, then, has a documentary quality without the specificity and coded rhetorical stance of documentary photography. The recognizable British soldiers in many of the billboards immediately identified them in the London context as having to do with the Irish question "out there," as in the soldiers with megaphones standing behind a barbed wire fence in *Block God*; or the conferring, huddled groups of jittery reinforcements in *Attack God*.

In other works, *Play God,* for example, the business community of arms merchants with their bowler hats are placed into question as the instigators of war for profit. In *Kill God,* two little boys square off with toy rifles in a simulated enactment of what might occur in the real world of terrorism and violence as they reach manhood. In *Torture God* no human beings are depicted; the words are placed between an opened stone gate. In the distance we see suggestive ominous prison blocks in which the activity of torture might take place, out of view.

The *Blame God* campaign aroused a great deal of anger. Some of the billboards were repeatedly vandalized, and at a certain point the billboard contractor refused to continue to place them because of the coercive phone calls his firm was receiving, but finally relented. Perhaps the most pointed commentary of the situation can be seen in Levine's documentation photographs and laser-scan paintings of the vandalized *Attack God*

billboard adjacent to a pristine Rambo billboard. He says:

The project forced people to have an inquiring attitude. They'd say or think "Well, why is God an issue now?" It freed the mind...(For me) there was an element of mental risk involved here, a frightening mental risk. I asked myself "What are you permitted to advertise? What image are these works/acts going to project of me to the public? It was an uncomfortable situation. I had to give myself the permission to become uncomfortable...to generate dislike. I wrestled with the rightness or wrongness of the *Blame God* project. I resolved it this way: the extremity, the absoluteness of the position clarified things for me...The extremity was appealing.[14]

The *Blame God* project must be viewed in light of a pantheistic belief system that lies outside the Judeo-Christian framework, not within a theistic or atheistic viewpoint, in order for its richness and complexity to become evident. Pantheism is the non-dualistic understanding of a totality one can call "god." It encompasses such understanding that everything we can touch, see, and eat is an aspect of god and that causing harm to anything or allowing harm to occur also harms the totality of god. As a noted scholar pointed out:

[Blame God] refers in part to the allegedly religious nature of the war, and in part to dualistic uses of religion for violence,

DN What's the difference between impersonalization and depersonalization?

LL Impersonalization implies that you don't impose any other mind structure on information. You don't neuroticize it in relation to the mental condition you find yourself in. You see it as a piece of information. Depersonalization means that you are in neurotic opposition to it. In other words, you're taking it much too personally. If you're depersonalizing it much too personally, you're rejecting it as though it were seducing you. Whereas if you're simply impersonal it means that it hasn't succeeded in arriving at a level of desire in terms of your scheme of the world. It's not potent enough as an entity to connect you, and it doesn't in any way attack your sense of who you are as an individual—it's just something that happens. But depersonalizing definitely means that you want to go through a process of neurotic rejection. I don't think this is what's

43

14 Les Levine, interview with author, March 22, 1990.

such as the idea of killing for god. The pantheistic idea that to kill anything is to kill god is implicity opposed in the work to the theistic idea of killing for god, or with god on one's side. Through this theological opposition issues surrounding the war in Ireland are succinctly posed. Levine is interested in the fact that the war in Ireland is commonly called a religious war—a designation that suggests that the Irish are backward, archaic and irrelevant. Assuming that all wars, no matter what their propaganda claims, are about greed or access to wealth, Levine is criticizing both the religious attitude of killing for god and the British propaganda claim that the war really is about religion.[15]

The major billboard campaigns that have been touched upon, *We Are Not Afraid* (1982), *Aim, Race, Take, Steal, Forget* (1982-83), *Mass Media* (1985), *Blame God* (1985-86), *Forgive Yourself* (1987), *Consume Or Perish* (1988-89), *Pray For More – Consume Or Perish* (1989), *Brand New* (1989), and *The Dortmund Project* (1989) have successfully bridged the worlds of art and advertising.[16] Each of these major efforts has effectively and directly communicated with the public, and has, to some degree, influenced or moved the public mind. As we have seen, there appear to be themes running through each campaign, such as urban fears and courage, bad faith, civil strife, the consumer ethos and self-knowledge, nationalistic self-appraisal, and those themes have wrapped themselves around broad philosophical, social, ethical, political, and religious issues. These concerns, so ably

15 Thomas McEvilley, *The Collaboration of Word and Image in the Art of Les Levine* (London: Institute of Contemporary Art, 1985), p. 3.

16 The billboard campaigns that have not been touched upon in this essay are *Retreat* (1985), Ossining, NY; *Breathe Take Space* (1986), Indianapolis; *Create Yourself* (1988), Lucerne; and *Authentic Desire* (1988), Indianapolis.

presented by Levine on the surface of his works, are contrivances, albeit brilliant ones, just as his image-texts are masterful contrivances that have been skillfully devised in order for him to reconcile the humanist and theoretical needs of a post-industrial, media-saturated world. Levine wants to communicate on a very deep level, on a level that goes beyond the actuality of the words or the indexical quality of the photographically-based images he uses. The art-world references or the social inferences that float on the surface of his works are the touchstones of his art's transformative power.

Just as it would be foolish to consider only the language or only the images in Levine's work, and just as it would be misguided to read Levine's choice of words as descriptive or novelistic or narrative or analytical (instead of metaphorical), so the point of Levine's achievement would be missed were one to misconstrue the generous state of incompleteness that surrounds each of his works. The persuasiveness of Levine's oeuvre lies in its conundrums. It is its capacity to arouse a flow of non-dualistic thought that makes the work truly transformative, and truly socially relevant. Levine's world reflects the fullness of life's possibilities and forces the mind to wrestle with itself. How could it be otherwise? We're hooked: Through his understanding of mass media codes, Levine draws the eye, commands the eye, to pay attention to a vision of the world that is simultaneously obvious and enigmatic, combative and funny, aggressive and innocent, persuasive and seductive. It is a work whose vision is generous and whose impact is immediate and powerful. We need all of it we can get.

Dominique Nahas, *Guest Curator*

happening with younger people. They're not depersonalizing...

DN Are they impersonalizing?

LL Yes, because their notion of what is personal is different. They arrived in a different period of history and they arrived with more access to information. They don't think it's all that important to get all that heavy about everything. They don't think that everything that happens is a reason to get personally involved, because too many things are happening. They do make choices, however, about things that they do want to get involved with. But they're much more easily capable of fluffing over things that older people would take seriously. The young see it as a very complicated world, with a lot of information. It has to do with the interior and exterior notion of possessiveness. It all relates to the individual's body as a projection of their individuality. The body, in the long run, is the strongest symbol of individuality. The idea that my body is in my

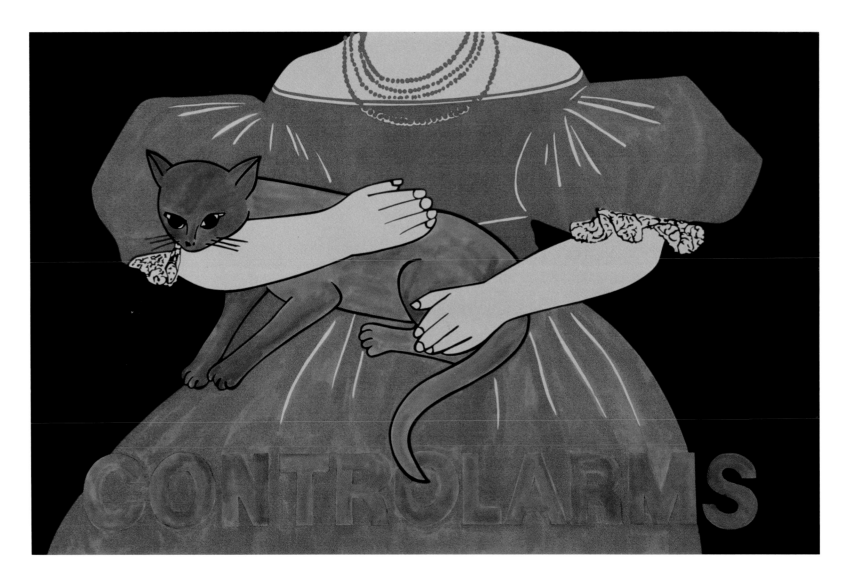

Control Arms, 1989. Watercolor, 26 x 41 in.
Courtesty Brigitte March Galerie, Stuttgart.

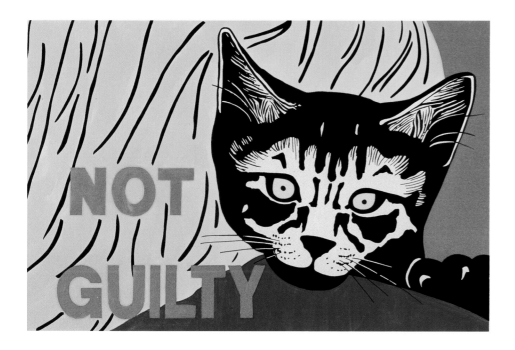

Not Guilty, 1989. Watercolor, 26 x 41 in.
Courtesy Mai 36 Galerie, Lucerne.

body and your body is in your body seems to be a holdover from a nineteenth century concept. "*This* is my body"..."*I am the one who is looking, and I am the one who is seeing, the one who is feeling...*" It's not so much that that's not true—it *is* true—but what's wrong with it and what's different is that it's excessively possessive.

DN For this time...

LL For a period where the level of send and receive has gone up phenomenally. It's impossible to possess all of this because it's going back and forth too quickly. So there are certain things about it that are on a possessive level. These things will define you based on your individual attitudes. But for the most part it seems to me that there's no way for people of this time to be like people of twenty-five years ago. No way. We're not talking about a shift in the level of intensity, we're talking about a different type of level of intensity.

Installation views of *Analyze Lovers—The Story of Vincent* at the Centraal Museum, Utrecht, 1990. The multimedia installation included a 41-minute videotape and 13 billboards, 68 x 188 in. each.

Analyze Lovers—The Story of Vincent, 1990. Videotape, color, 41 mins. With Catherine Galasso as the child.

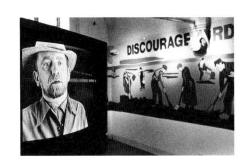

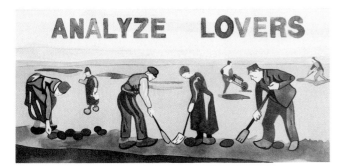

ANALYZE LOVERS

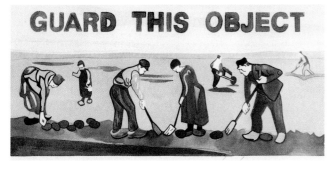

DO ABSOLUTELY NOTHING

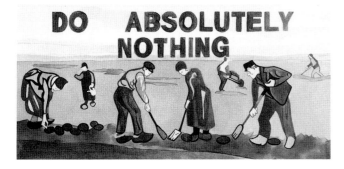

GUARD THIS OBJECT

Cartoons for the billboards *Analyze Lovers, Do Absolutely Nothing,* and *Guard This Object,* 1990. 4 7⁄8 x 9 7⁄8 in. each.

The major shift is the shift in access. Most of the information we're dealing with today, on a very democratic level, was not available in this form previously. *Access* as a conceptual basis, as a medium, changes things dramatically. *Dramatically.* Because your behavior can be one thing with a tiny bit of access. With an enormous amount of incoming information and an enormous amount of necessary responses, your behavior *has* to change. It just has to. And if you're not going to change, you'll end up like a piece of driftwood or something. That must be quite evident to everyone now. If you get a fax today, you've got to *fax* back.

I've just gotten back from Europe—there's no information gap anymore, there just isn't. There was a parabolic dish on the roof of my hotel—I was getting every American and European channel. In

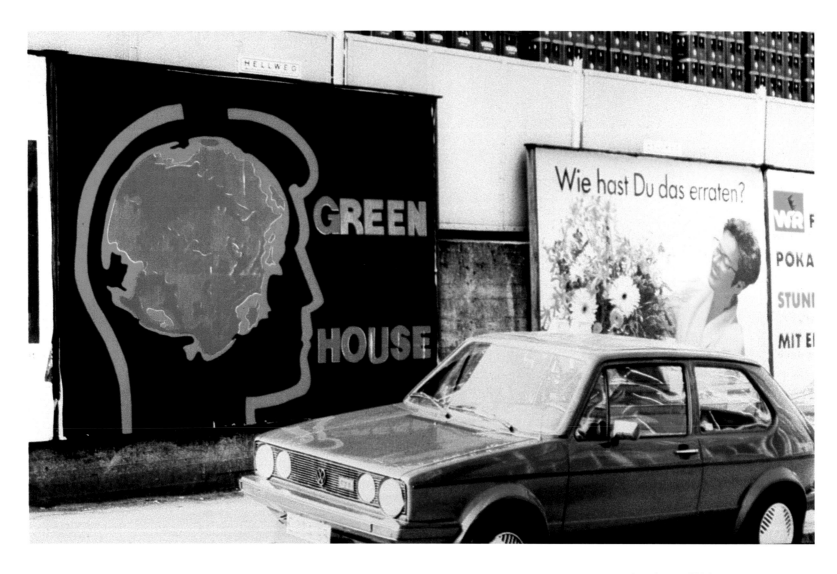

Green House, 1990. Computer-scanned laser jet
painting of Dortmund project, 1989, 77 x 108 in.

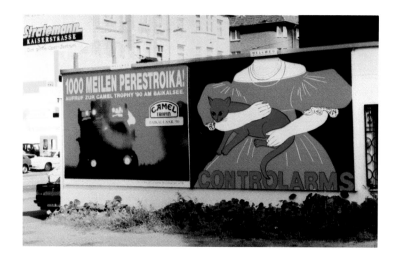

Control Arms-Perestroika, 1990. Computer-scanned laser-jet painting of Dortmund project, 1989, 73 x 114 in.

the age of media, one can become a fan of whatever information that can enter the media, at any level.

The other thing is that people are not as interested in reality anymore. People like Lévi-Strauss, or these French deconstructivists who talk about reality, talk about reality as if it were something tangible, stopped in time; which is based on the structure that preceeded it in some way or another. Whereas a fifteen year old's notion of reality is one that lies between what is synthesized as reality, images made, and what is *actually* reality, what can be touched or felt as sensate experience for the body; it's very vague. One isn't sure if the reality model has been invented for simulation or if the simulation is constructed to encourage one toward a certain reality.

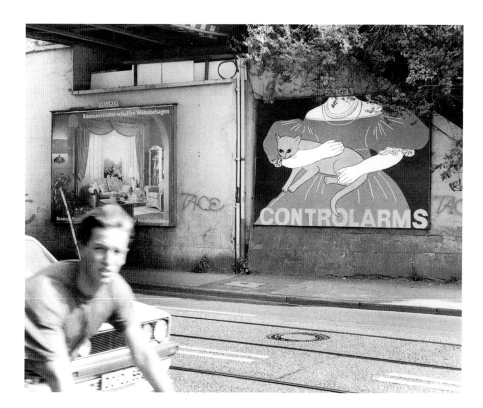

In situ photograph of *Control Arms,* 1989. Part of *Green House* and *Control Arms,* an outdoor billboard campaign installed in Dortmund, West Germany, consisting of 25 examples of each billboard, 120 x 156 in. each.

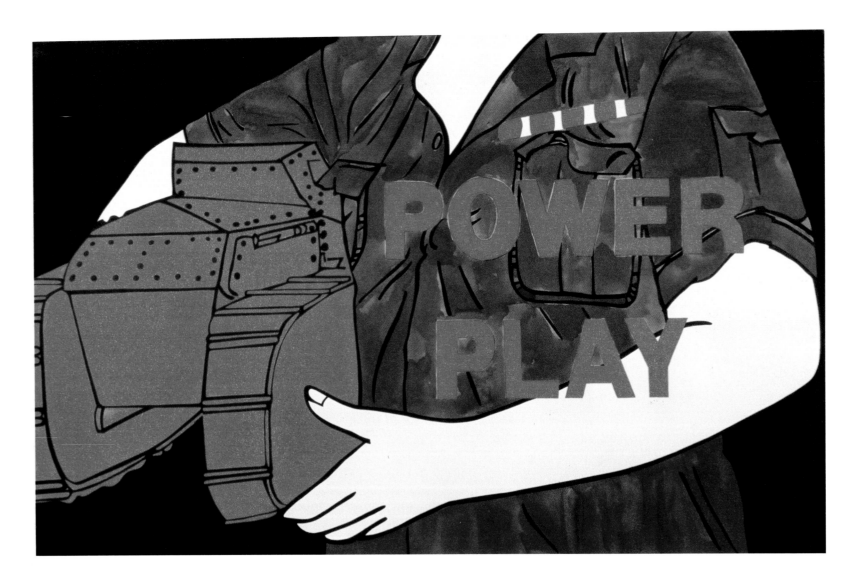

Power Play, 1989. Watercolor, 26 x 41 in.
Courtesy Mai 36 Galerie, Lucerne.

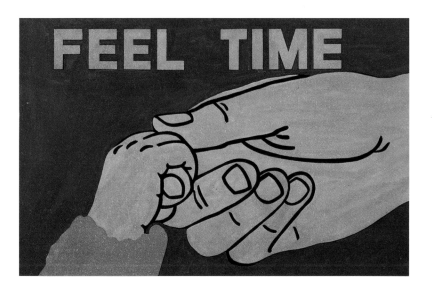

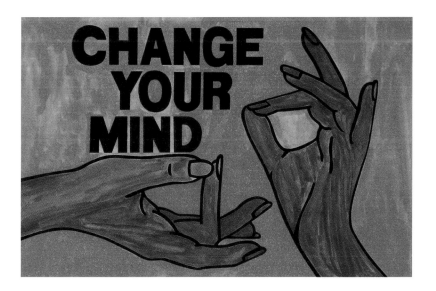

Feel Time, 1989. Watercolor, 26 x 41 in.
Courtesy Brigitte François, Switzerland.

Change Your Mind, 1989. Watercolor,
26 x 41 in. Courtesy Mai 36 Galerie, Lucerne.

I don't think you can use the word *reality* as it was used twenty-five years ago, or as it was used by the novelists. There really is no longer a pronounced distinction between simulation and reality. We're no longer sure which one came first and what is the point, in the long run. Do we want to invent a society that looks like television, or is television inventing a society that looks like it?

It's really interesting how people want to blame media. I see media differently, as a kind of metaphor for the religious ritual of previous times: Before an action could be taken in society, a ritual would have to occur in order for this to become a positive action, and to empower those who wanted permission to take it. Media is very much what we want it to be, based on what we imagine it should be. In the long run, media does have an enormous power to replace previous myth and rituals, and to create instantaneous myth out of

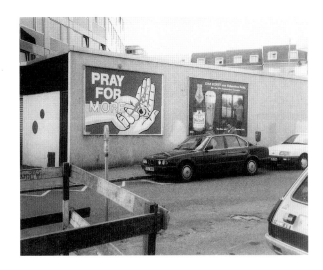

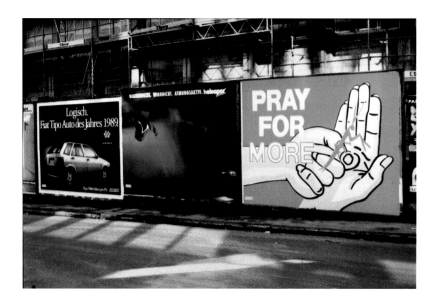

In situ photographs of *Pray for More* 1989. Part of the
Consume or Perish, Pray for More, and *Feed Greed*
outdoor billboard campaign, consisting of ten
billboards installed in Dijon, France (1988), and
Stuttgart, West Germany (1989), 120 x 156 in. each.

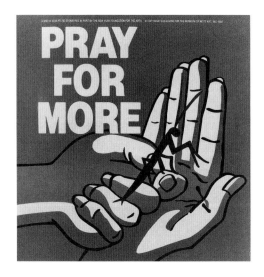

Pray for More, 1989. Offset printed placard,
21 x 21 in. Part of *Consume or Perish* and *Pray for
More,* a two-month media sculpture in the IRT, BMT,
and IND New York subway cars; consisting of 4,800
premium square advertising spaces, 21 x 21 in. each.

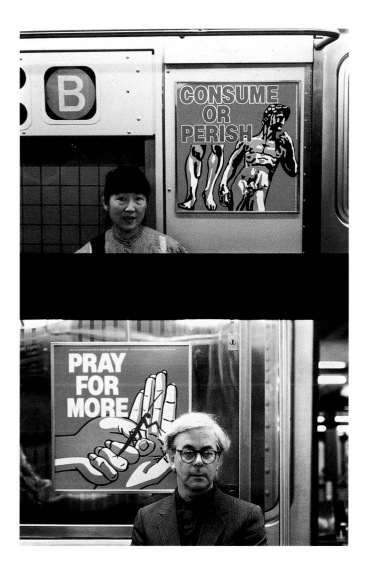

Portrait of Catherine Levine with *Consume or Perish* and Les Levine with *Pray for More,* 1989. In situ documentary photographs from the New York City subway project.

which people can operate.

DN What's the source?

LL Its source is understanding whatever primal anxiety the society is operating within. This is not any different from the way it was prehistorically. The point is that prehistorically, someone went out with a spear to kill an animal but painted those animals beforehand to empower oneself and to take away the evil of killing. I think television is continually trying to respond to a similar level of mythic need. It's simply unfortunate that it's doing it at a pace that is much faster than we're willing to accept or digest. It doesn't take into account the time. The value of most ritual, religious or cultural, is that it takes a certain amount of time to wrap the individual up, to come out of the ritual empowered. You don't have that in television, where time

55

In situ photograph of *Consume or Perish,* 1989. Part of *Consume or Perish* and *Pray for More,* a two-month media sculpture in the IRT, BMT, and IND New York subway cars; consisting of 4,800 premium square advertising spaces, 21 x 21 in. each.

In situ photographs of *Feed Greed* and *Consume or Perish,* 1988. Part of the *Consume or Perish, Pray for More,* and *Feed Greed* outdoor billboard campaign, consisting of ten billboards installed in Dijon, France (1988), and Stuttgart, West Germany (1989), 120 x 156 in. each.

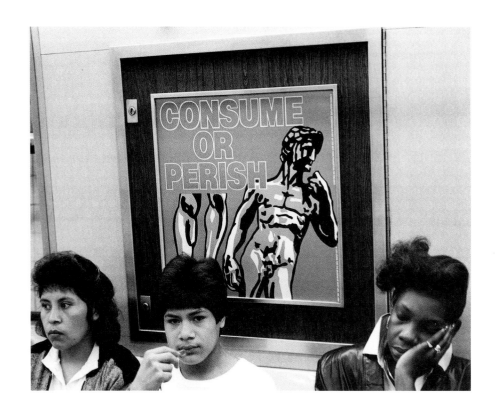

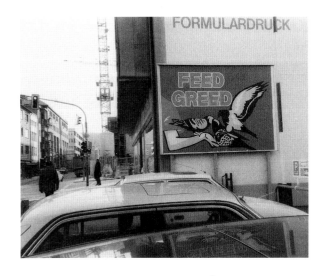

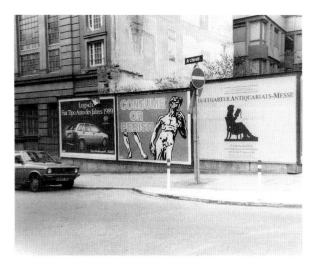

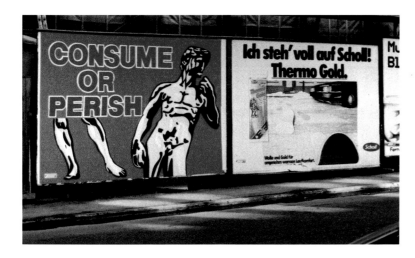

Consume or Perish, 1989. Computer-scanned laser-jet painting of the Stuttgart project, 1989, 65 x 115 in.

is crushed and condensed. You're in France one second, California the next second...those two fractions of time are butt-cut, one next to the other. And so you don't have the sense of time. Nevertheless, I think you are given a sense of empowerment, you are permitted to take the actions which are presented.

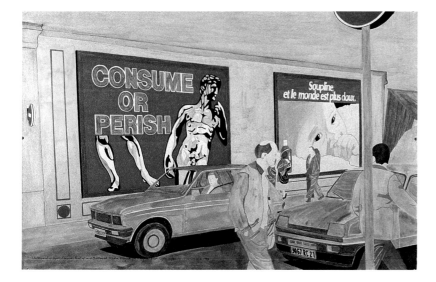

Consume or Perish, 1988. In situ documentary watercolor from the Dijon project, 26 x 41 in.

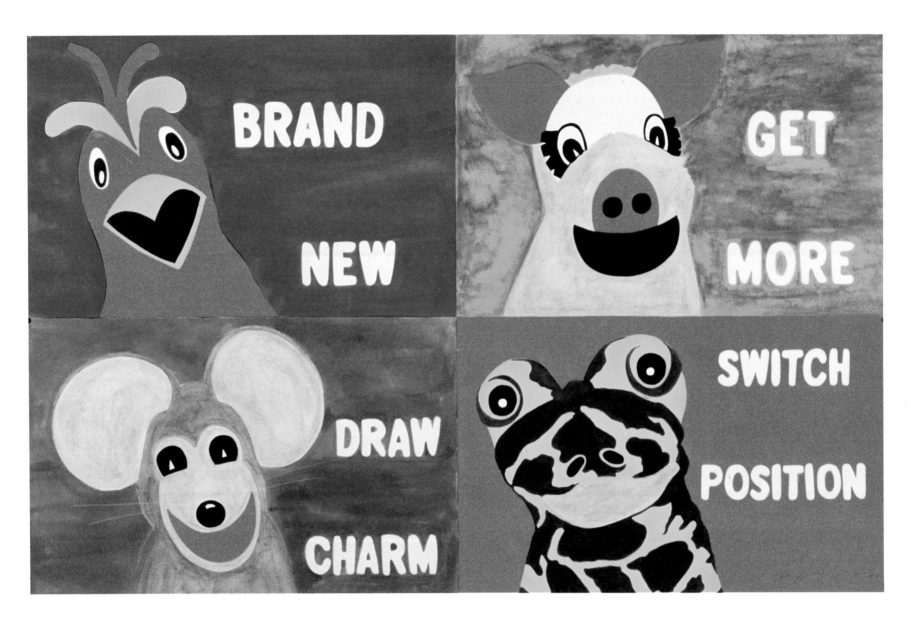

The four images of the *Brand New* project, 1989.
Watercolor, 26 x 41 in.

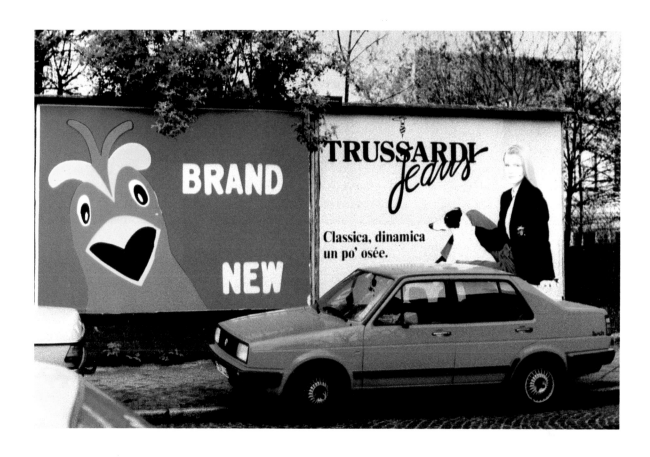

Brand New, 1989. Computer-scanned laser-jet painting of the *Brand New* project in Frankfurt, 1989, 86 x 114 in.

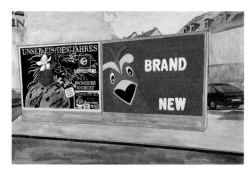

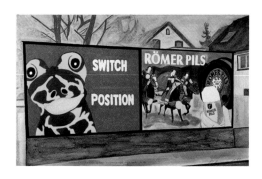

Brand New and *Switch Postition-Romer Pils,* 1989. In situ documentary watercolors from the Frankfurt project, 24 x 41in. each.

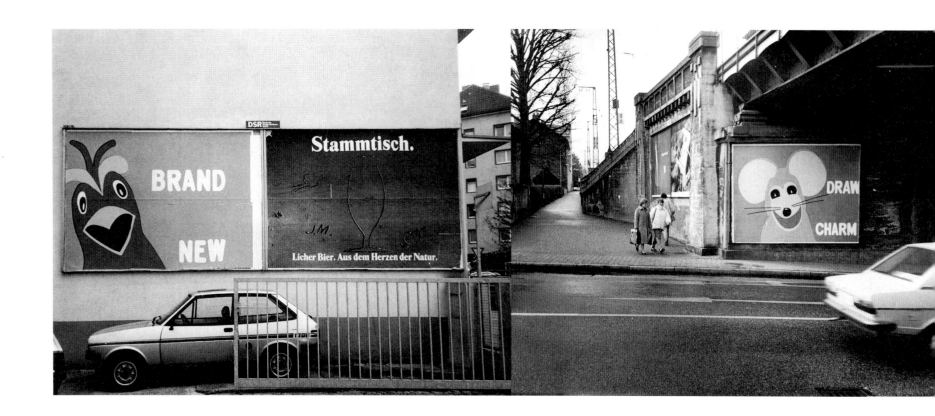

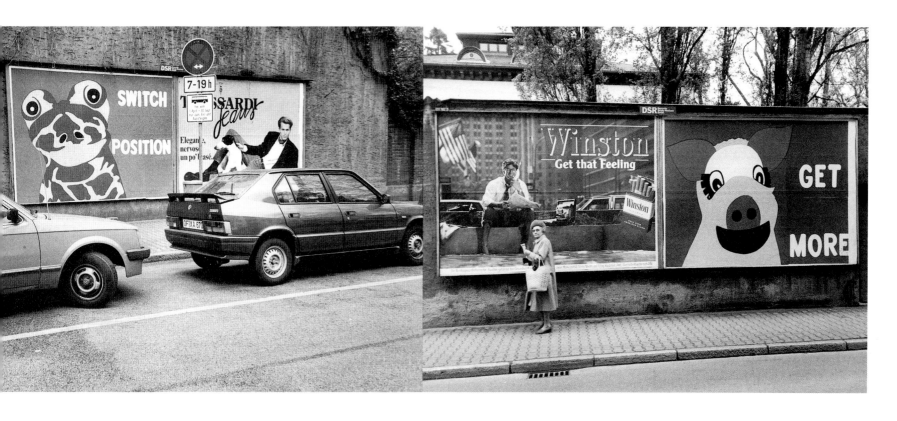

In situ photographs of *Brand New, Draw Charm, Switch Position*, and *Get More*, 1989. Parts of the *Brand New* outdoor billboard campaign consisting of 200 billboards installed in Frankfurt, West Germany, 120 x 156 in. each.

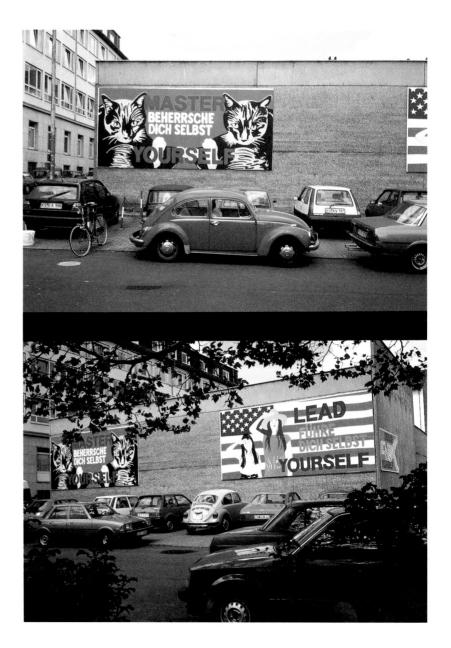

Two in situ views of the *Forgive Yourself* outdoor billboard campaign for Documenta 8 in Kassel, West Germany, 1987. The campaign consisted of thirty 120 x 251 in. billboards.

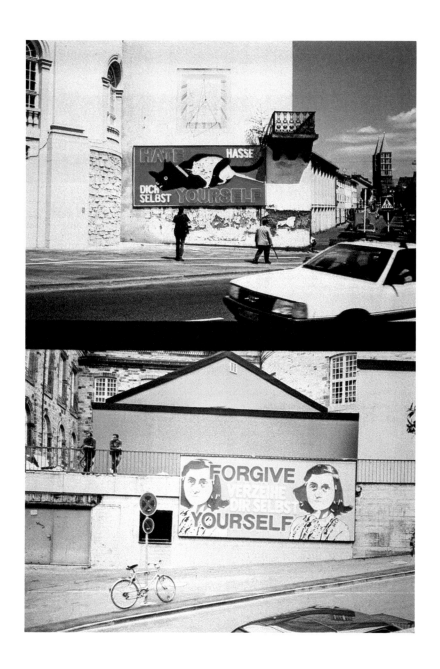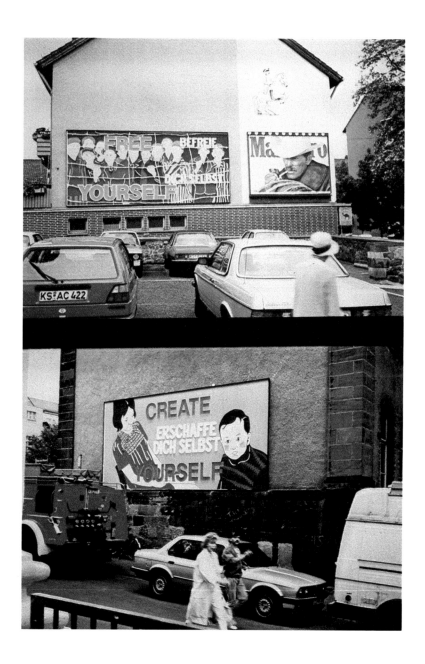

Hate Yourself and *Create Yourself,* 1988. Computer-scanned laser-jet paintings of the *Forgive Yourself* project for Documenta 8 in Kassel, West Germany, 1987, 120 x 78 in. each.

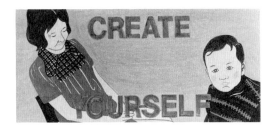
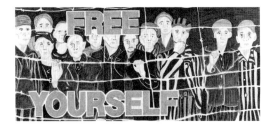
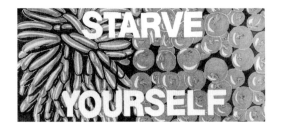

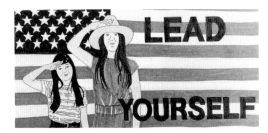

Cartoons for the *Forgive Yourself* billboards, 1987.
4⅞ x 9⅞ in. each.

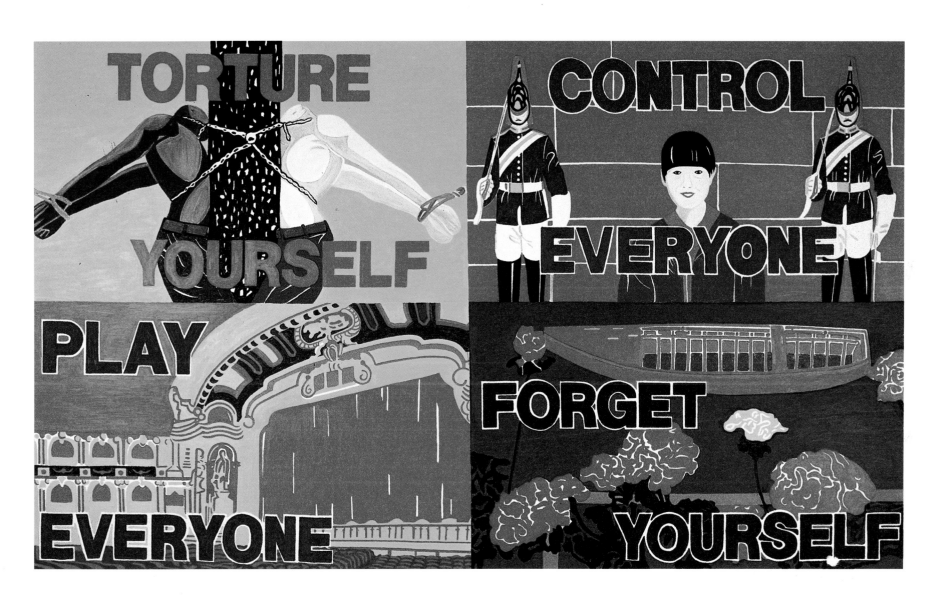

Torture, Control, Play, Forget, 1987.
Oil stick on canvas, 68 x 114½ in.

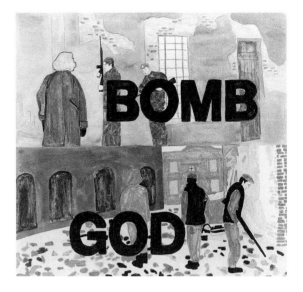
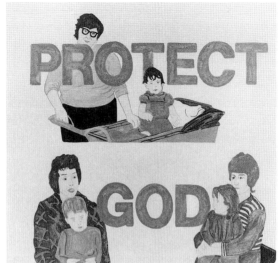
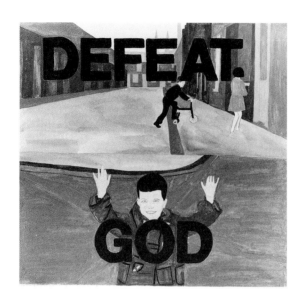
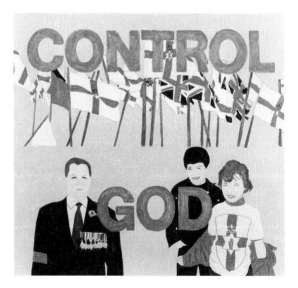
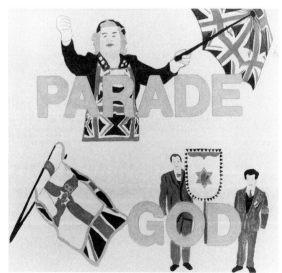
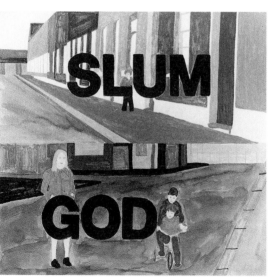

Cartoons for the *Blame God* billboards, 1985.
10 x 10 in. each.

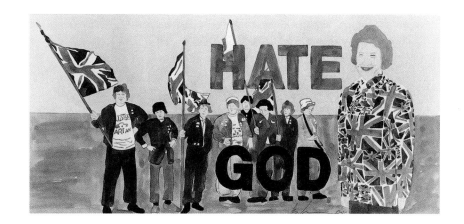

Cartoons for the *Blame God* billboards, 1985.
5 x 12 in. each.

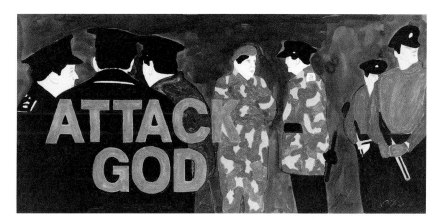

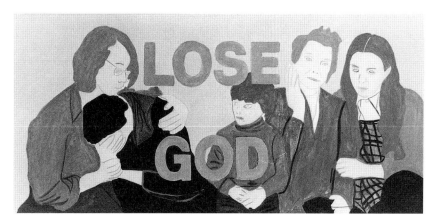

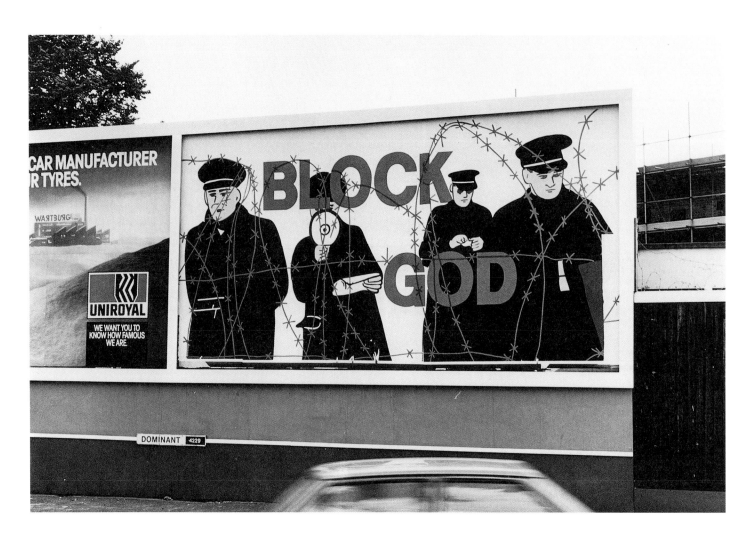

In situ photograph of *Block God,* 1985. Part of the
Blame God outdoor billboard campaign, consisting of
28 billboards installed throughout London, 120 x
252 in. each, and an exhibition at the Institute of
Contemporary Arts in London.

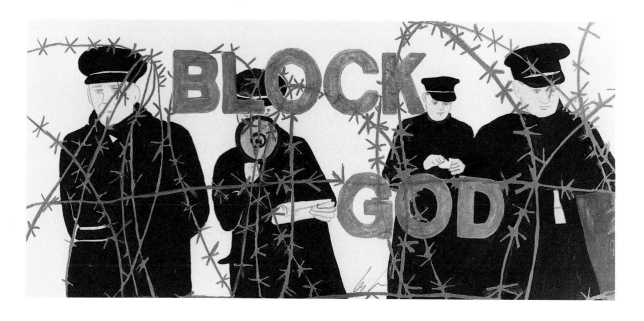

Cartoon for the billboard *Block God,* 1985.
5 x 12 in.

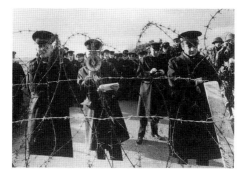

The Troubles: An Artist's Document of Ulster,
"Police Roadblock at Civil Rights March," 1972.
Photograph, 8 x 10 in.

The Troubles: An Artist's Document of Ulster,
"People's Room," 1972. Mixed-media, including
photographs, sound, barbed wire, and video.
Installation at Finch College Museum,
New York, 1972-73.

The Troubles: An Artist's Document of Ulster,
"Sean Shannon Plays with a Tommy Gun," 1972.
Photograph, 8 x 10 in.

In situ photograph of *Kill God,* 1985. Part of the
Blame God outdoor billboard campaign, consisting
of 28 billboards installed throughout London,
120 x 252 in. each, and an exhibition at the Institute
of Contemporary Arts in London.

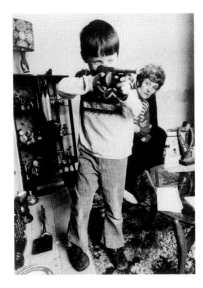

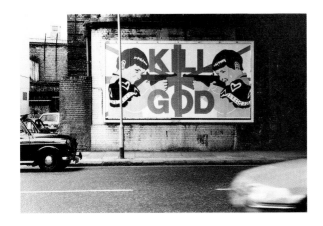

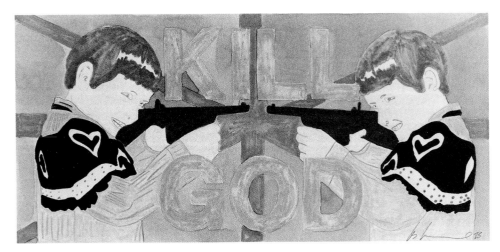

Cartoon for the billboard *Kill God,* 1985.
5 x 12 in.

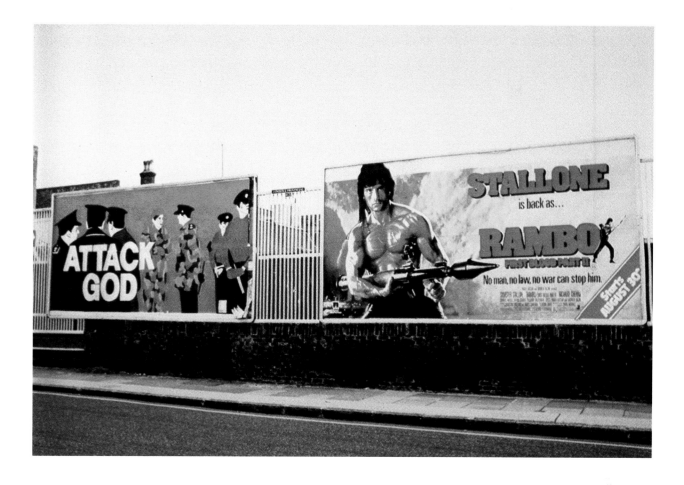

Attack God, 1986. Computer-scanned laser-jet painting of London billboard of 1985, 72 x 120 in.

The Troubles: An Artist's Document of Ulster, "Les Levine Discusses I.R.A. Press Conference with Belfast M.P. Paddy Kennedy," 1972. Photograph, 8 x 10 in.

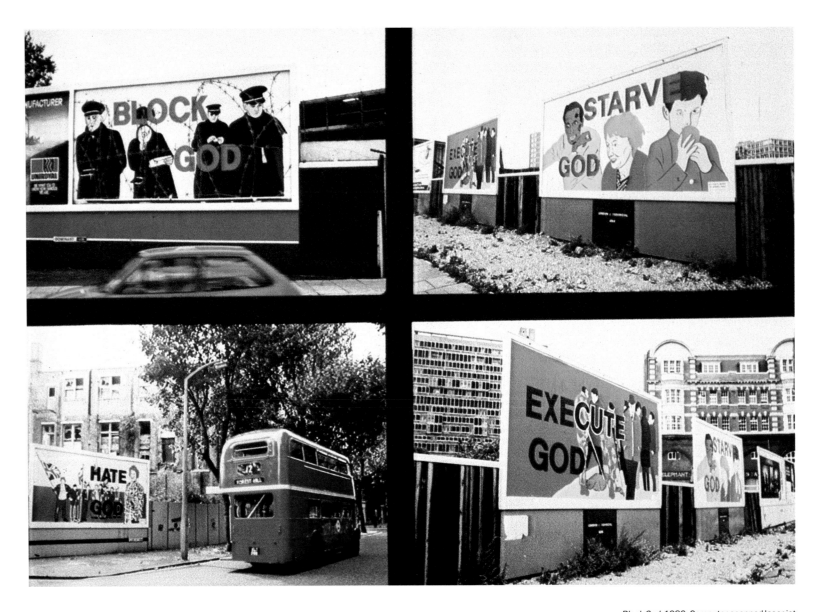

Block God, 1986. Computer-scanned laser-jet
painting of London billboards of 1985.
72 x 120 in.

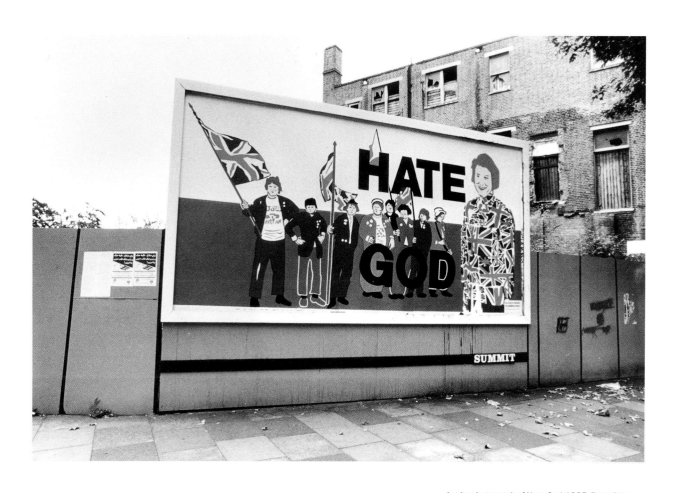

In situ photograph of *Hate God*, 1985. Part of the *Blame God* outdoor billboard campaign, consisting of 28 billboards installed throughout London, 120 x 252 in. each, and an exhibition at the Institute of Contemporary Arts in London.

The Troubles: An Artist's Document of Ulster, "Protestant Extremist," 1972. Photograph, 8 x 10 in.

Giant Computer Assisted Drawings, 1985.
Oil stick on canvas, 96 x 84 in. each.
Installation view at Carpenter + Hochman Gallery,
New York, 1986.

Starve Feed Greed, 1985. Computer assisted
oil stick drawings on canvas, 96 x 84 in. each.

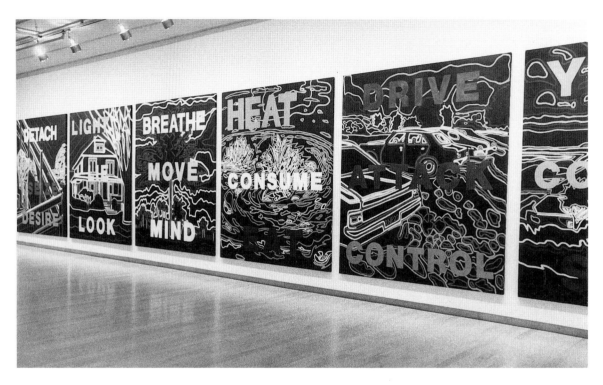

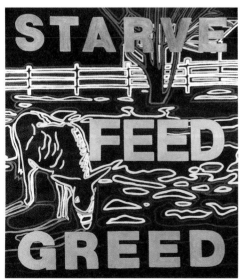

Every Child Has Been Our Parents in a Previous Lifetime,
1986. A major outdoor billboard campaign in Staten
Island, consisting of twenty 120 x 252 in. billboards.

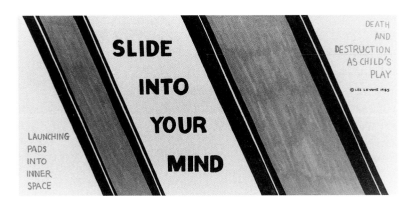

Slide Into Your Mind, 1985. Billboard,
120 x 252 in., and 3 slides, 156 in. high each.

Cartoon for the billboard *Slide Into Your Mind,*
1985. 4⅞ x 9⅞ in.

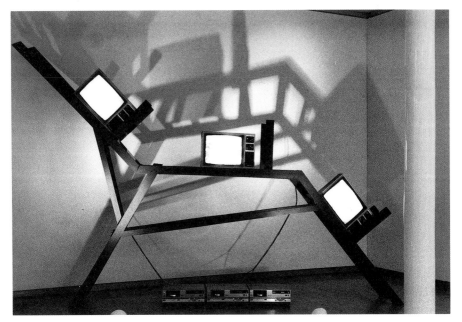

Installation view of *Einstein: A Nuclear Comedy*
(1985) at Carpenter+Hochman Gallery, New York,
1986. The video installation included the videotape
produced in 1983, three televisions, and a wooden
structure, 108 x 156 x 24 in.

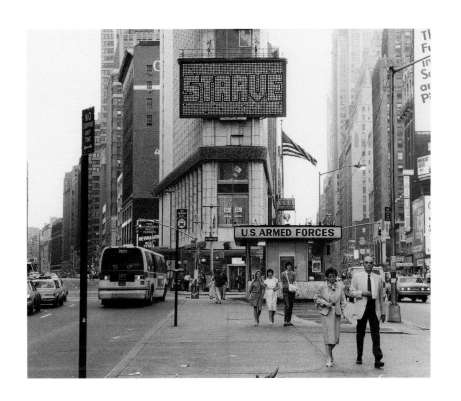 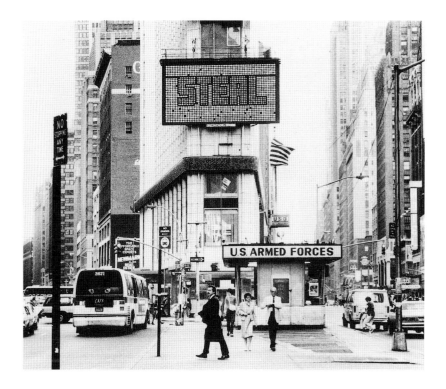

Media Mass, 1985. Spectacolor light board,
Times Square, New York (outdoor electronic advertisements).

Cartoons for the *Aim, Race, Take, Steal, Forget* billboards, 1981. 4⅞ x 9⅞ in. each.

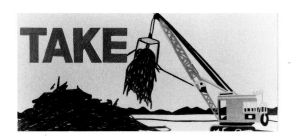

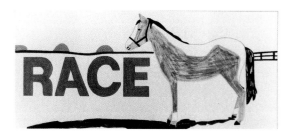

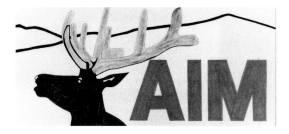

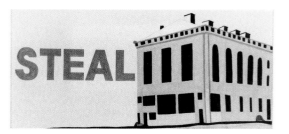

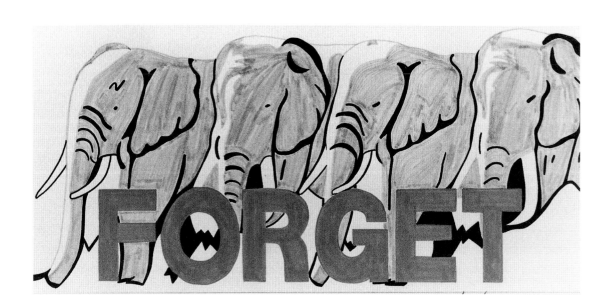

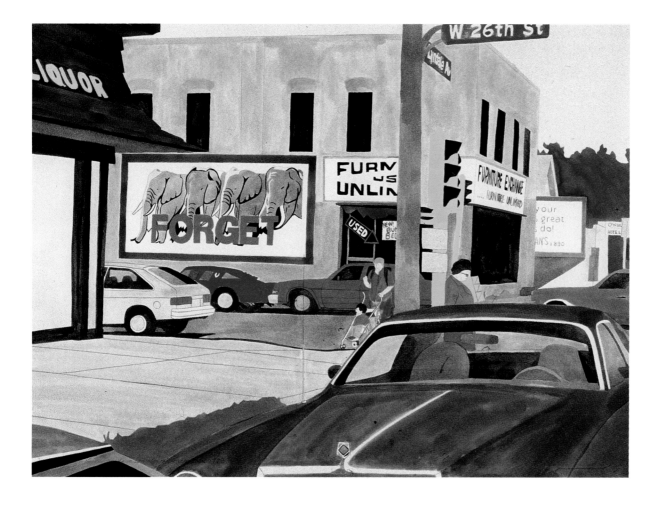

Forget, 1984. In situ documentary watercolor from the Minneapolis project, 20 x 30 in.

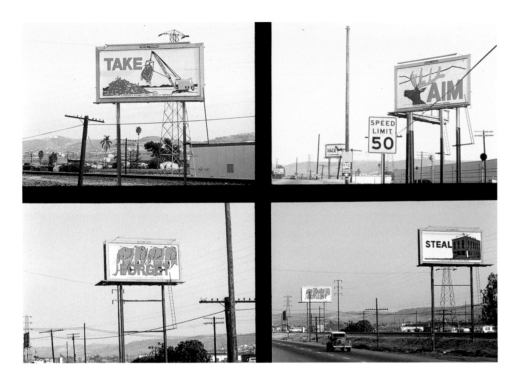

Race, 1982. Part of the *Aim, Race, Take, Steal, Forget* outdoor mass-media billboard-campaign installation in Minneapolis, consisting of twenty 30-sheet billboards, 120 x 252 in. each.

In situ views of the *Aim, Race, Take, Steal, Forget* outdoor billboard campaign in Los Angeles, 1984, as seen along the highway in the City of Industry. The campaign consisted of fifteen 30-sheet billboards, 120 x 252 in. each.

Aim, Race, Take, Steal, Forget, 1986. Computer-scanned laser-jet painting of Minneapolis billboards, 1982.

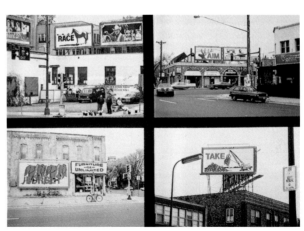

Take, 1983. Polaroid photograph, 24 x 20 in.

Signal, 1983. Polaroid photograph, 24 x 20 in.

Mind, 1982. Plasticine model, 30 x 20 in.
Cover for the *Village Voice*, June 9, 1982.

Mind, 1982. Oil stick on canvas, 132 x 90 in.

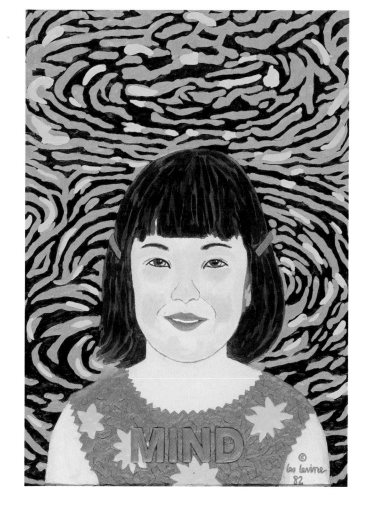

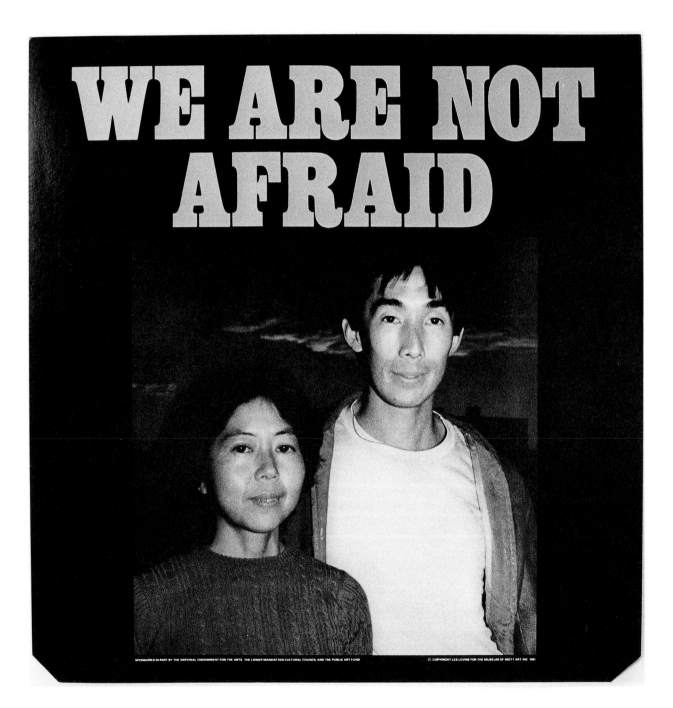

We Are Not Afraid, 1979-81. Offset-printed premium square for mass-media advertising campaign in New York City subways, 21 x 21 in.

Proposal drawing for We Are Not Afraid, 1978, 22 x 30 in. A proposal for a mass-media campaign for the New York City subways.

We Are Not Afraid, 1979-81. 21 x 21 in. premium square in situ on the BMT subway line, New York, 1982.

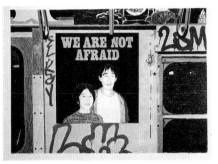

Visions From the God World, 1979-81.
Five videotapes, color, 30 mins. each.

Visions From the God World, 1981. Multimedia,
including 6 photo panels and video sculpture.
Video sculpture measures 100 x 18 x 24 in.

Visions From the God World, 1981. Multimedia,
including 6 photo panels and video sculpture,
96 x 120 in. each.

Race, 1978. Oil stick on canvas, 84 x 112 in.

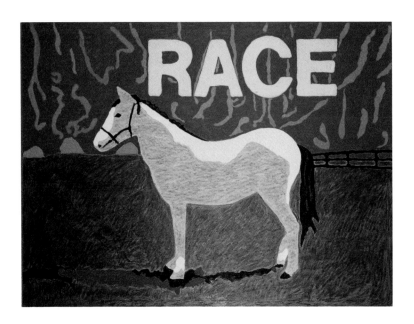

The Cat Is On Her Shoulder, 1978.
Oil stick on canvas, 72 x 156 in.

Grow and *Race,* 1980. Plasticine models for billboard designs, 18 x 22 in. each.

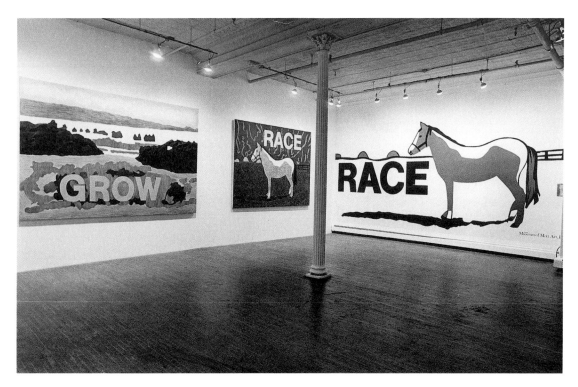

Installation view of *New Media Projects* at Ronald Feldman Fine Arts, New York, 1983. Includes *Grow* (1978, oil stick on canvas, 90 x 132 in.), *Race* (1978, oil stick on canvas, 78 x 96 in.) and *Race* (1982, billboard, 120 x 252 in.).

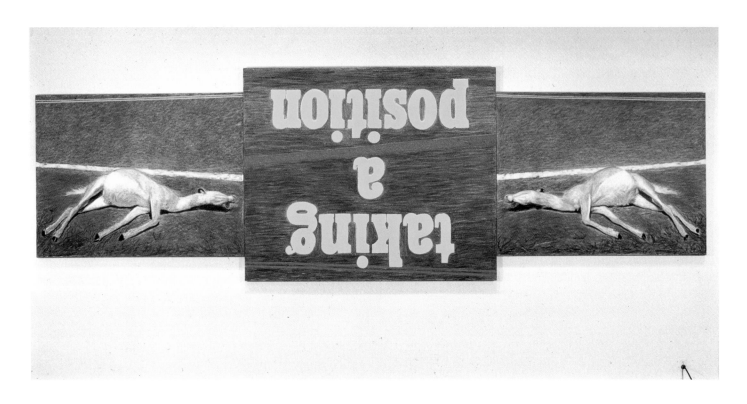

Taking a Position, 1979.
Oil stick on canvas, 96 x 234 in.

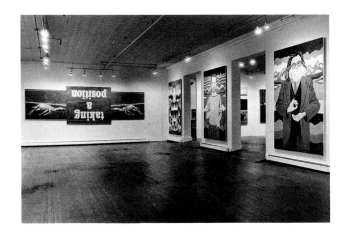

Installation view of *New Media Projects* at Ronald
Feldman Fine Art, New York, 1983.
Includes *Taking A Position* (1978, 96 x 234 in.) and
Signals (1982, 120 x 78 in. each).

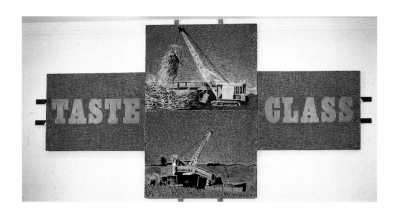

Taste Class, 1979. Oil stick on canvas, 120 x 224 in.

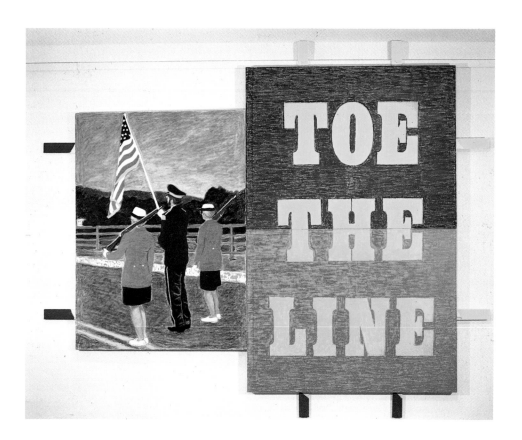

Toe the Line, 1979. Oil stick on canvas, 108 x 132 in.

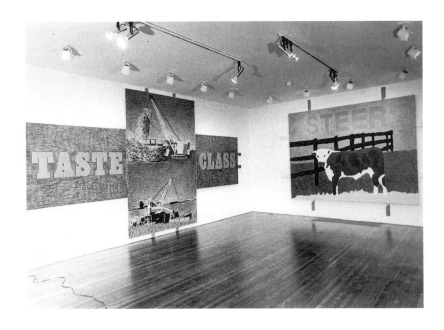
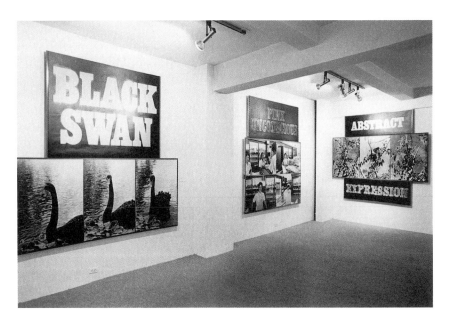

Country Billboards, 1981.
Installation view at Ronald Feldman Fine Arts, New York

Ads, 1980. Installation at
Marian Goodman Gallery, New York.

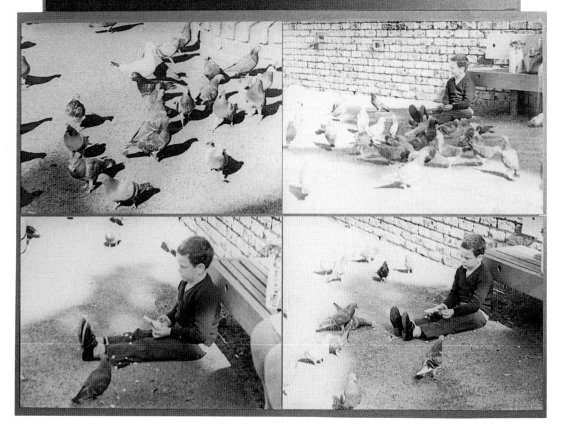

A Boy Making Sculpture, 1979.
Color photographs on wood, 90 x 74 in.

Deep Gossip (detail), 1979. Video installation including videotape and household furniture.

Deep Gossip, 1979. Videotape, color, 60 mins.

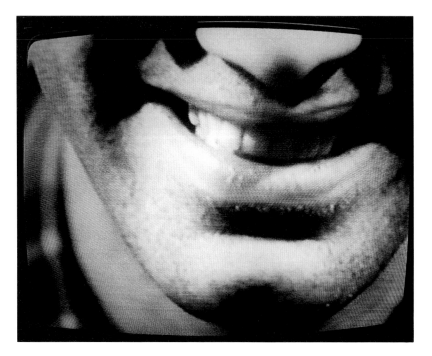

House of Gloves, 1977. A media sculpture including a house made of gloves and videotape, 132 x 108 x 144 in. Installation at Ronald Feldman Fine Arts, New York, 1978.

House of Gloves, 1978. Videotape, color, 5 mins.

 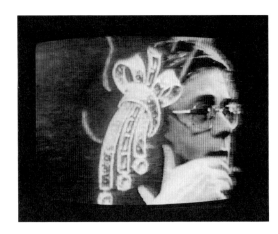

Diamond Mind, 1977. Multimedia, including
zinc plates, electronic message readers, and
video. Installation views at Ronald Feldman
Fine Arts, 1979.

Diamond Mind, 1977. Videotape, color, 30 mins.

Take, Steal, Win, 1978.
Oil stick on canvas, 78 x 96 in. each.

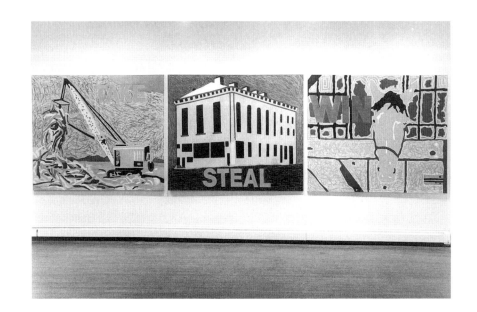

WHEN THE SON GOES OUT—GOOD LUCK. eleanor antin PLEASE SURVIVE. arman THAT RAINBOWS CONTINUE TO BE PRODUCED BY THE REFRACTION OF A NATURAL LIGHT SOURCE ON RAINDROPS. bill beckley WATCH THE SMOKE IT WILL TELL YOU WHERE THE AIR IS GOING. chris burden FOR IN THE ROOT OF WATERS IS CONCEALED THE FIRE OF THE FATHER. jack burnham MORE LIGHT. janet fish WE ARE ALL PRETTY WELL TAKEN CARE OF. ron gorchov ARBITRARY DIVIDING: ATTEND TO THE CONTINUITY OF WATERS. ARBITRARY DIVIDING: ATTEND TO THE CONTIGUITY OF LAND. ARBITRARY DIVIDING: ATTEND TO THE INTEGRITY OF WATERSHEDS. BEGIN AGAIN: PAY CAREFUL ATTENTION TO THE WEAVING. helen mayer harrison and newton harrison LOVE. robert indiana I WISH TO SEE YOU HEART TO HEART. joan jonas. SEE LL'UOY DNA RORRIM EHT NI KOOL allan kaprow I WISH FOR AN OCEAN WHERE WE WILL BE BORN AGAIN. shigeko kubota PIERCE THE HEART WITH A MAGIC DAGGER AND FIND THE DIAMOND. les levine MY WISH IS FOR PEACE AND UNITY IN THIS WORLD AND ALL OTHERS. jeffrey lew TO EARTH'S WARM LIQUID LIFE EXPLOSION...DON'T STOP...BATHERS ONLY. gordon matta clark MY HOPE IS FOR US TO ACHIEVE THE FULL MEASURE OF OUR HUMAN POTENTIAL. charlotte moorman KEEP ON TRUCKIN. malcolm morley WE SHOULD NOT MAKE ARTISTS A SOURCE OF BARGAIN BASEMENT PUBLICITY FOR BUSINESS. WE MUST GIVE THEM THE SAME ECONOMIC POSSIBILITIES AS CORPORATE EXECUTIVES. max neuhaus LET THEM BEAT THEIR MEAT 'N EAT THEIR FEET. charlemagne palestine I DO NOT CLAIM THAT THE (ABOVE) ARGUMENT IS IMMEDIATELY CONCLUSIVE. david rabinowitch IT'S A SMALL WORLD. larry rivers THE PARADOXICAL ABSOLUTE. robert ryman LET'S HOPE THE WORLD WILL KEEP ON WISHING. bernar venet HAVE A GOOD TRIP AND MANY HAPPY RETURNS. roger welch ULTIMATELY, RESPONSIBILITY DOES NOT EXIST: BUT WE MUST PRETEND THAT IT DOES. jack youngerman. copyright museum of mott art, inc., 1978.

Prayer Rug, 1978. Wool carpet including
the sayings of 21 artists, 144 x 108 in.
Collection Acey and William Wolgin, Philadelphia.

Making You In Our Image, 1978.
Multimedia, consisting of two tons of flour, three
slide projectors, and four images painted with jam

Proposal drawing for *Tired Earth*, 1978.
22 x 30 in. A proposal for an outdoor billboard campaign.

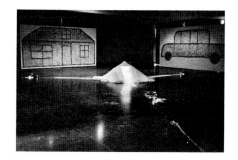

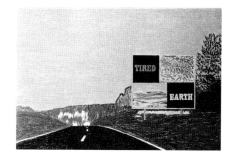

Bum, 1965. Videotape, b/w, 50 mins.

Artistic, 1974. Videotape, color, 30 mins.

Les Levine's Greatest Hits, 1974.
Videotape, color, 30 mins.

Brainwash, 1974. Videotape, color, 30 mins.

I Am An Artist, 1975. Videotape, color, 30 mins.

Visiting Artist (1974, color, 3 mins. 12 secs.) part
of *Performance 70's,* 1971-1983, containing
excerpts from 14 videotapes; color, 1 hr.

Disposable Monument, 1976.
Videotape, color, 17 spots, 30 secs. each.

The Selling of a Video Artist (1976, color, 4 mins.
16 secs.) part of *Performance 70's,* 1971-1983,
containing excerpts from 14 videotapes; color, 1 hr.

Media Mass, 1985. Videotape, color, 8 mins.

 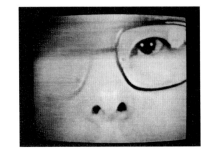 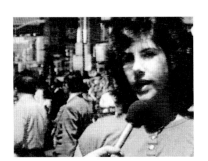

Einstein: A Nuclear Comedy, 1985.
Videotape, color, 22 mins.

Anxiety, Religion, and Art, 1985.
Videotape, color, 22 mins.

Close Frenzies, 1986. Videotape, color, 26 mins.

 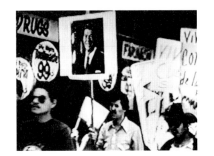

Untitled, 1961. Air brush drawing on paper,
30 x 32 in. Collection Walter Moos, Toronto.

Plug Assist, 1965. Vacuum-formed Plexiglas, 6 units, 84 x 44 x 30 in. each.

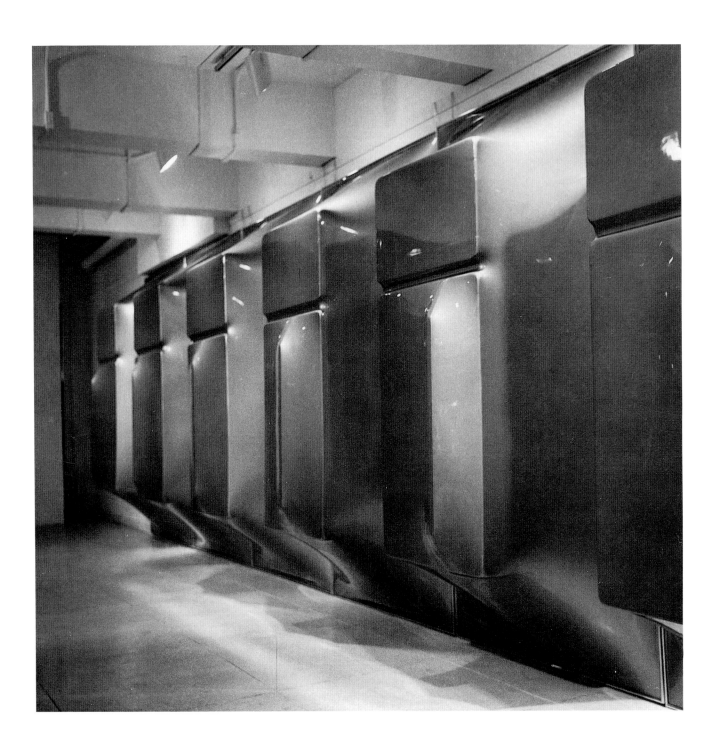

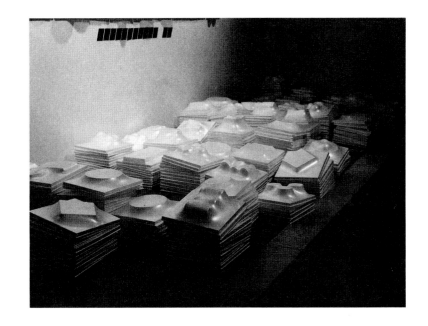

Disposables, 1962. Polyexpandable styrene,
12 x 12 x 8 in. each.

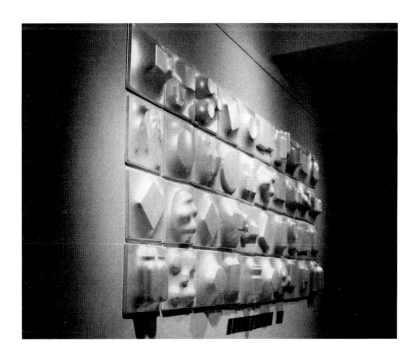

Disposables, 1966. Various plastic materials, various sizes. Installation at the Isaacs Gallery, Toronto, 1967.

Plug Assist, 1966. Vacuum-formed Plexiglas, 8 units, 50 x 34 x 24 in. each.

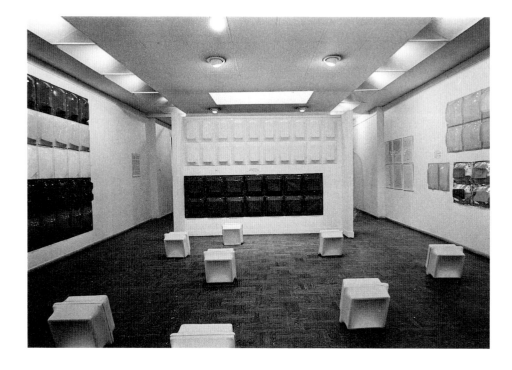

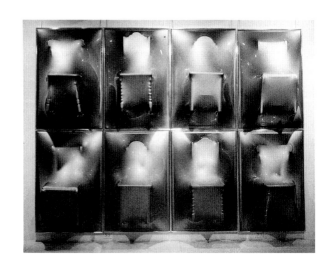

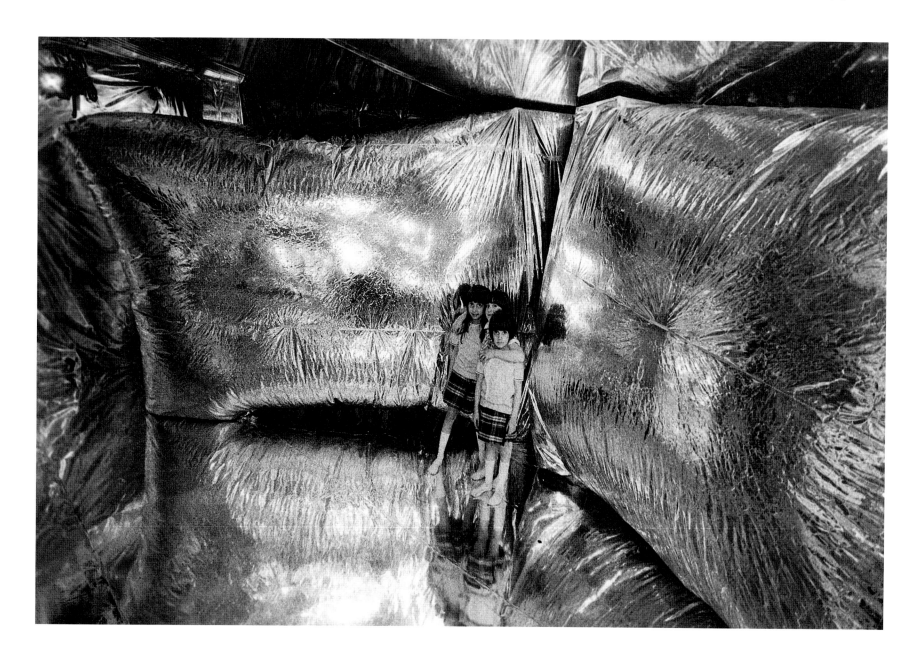

Slipcover, 1966. Installation at the Architectural League of New York, 1967. Multimedia installation including inflatable mirrored Mylar and video feedback and slide projections.

Process of Elimination, 1969. Consisted of 300 pieces of polyexpandable styrene, 24 x 24 in. each, spread on a lot next to New York University. Ten of these pieces were taken away each day for 30 days.

Systems Burnoff x Residual Software, 1969-70. Consisted of several thousand photographs of the *Earth Art* show in Cornell, with 50 gallons of Jell-O poured over them. Installation at the Jewish Museum, New York.

Paint, 1969. Sixty gallons of house paint, 360 x 168 in. Installation at the Molly Barnes Gallery, Los Angeles.

I: Plastic Man Arrives

 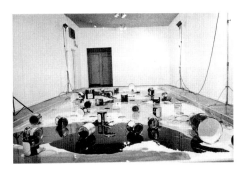

The sixties were not just about love beads, mini-skirts, long hair, and the Beatles. And the sixties, as a state of mind and a social and cultural era, did not end on midnight December 31, 1969. Although what people wear, what they listen to, and how they cut their hair are meaningful parts of history, it is a grievous mistake to let style subsume either the heroic or the tragic. In the sixties, all values were up for grabs. It was the time art became big business.

There was also a great flowering of experimental art: minimalism, earth art, conceptual art, video art, installations, and performances all proliferated. These are now established forms and to some of us as traditional as still lifes and portraits. At the time, some saw these forms as the end of art.

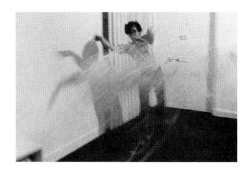

String, 1969. String performance work at the Sidney Janis Gallery, New York.

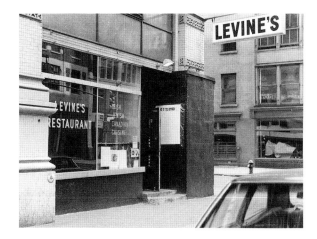

Levine's Restaurant, 1969. Restaurant based on a concept by Les Levine, including video and a special menu.

Currently a new generation of artists is reclaiming the discoveries of that period.

Was this explosion of new art inspired by the expansion of the art market? Or, since most of it was thought unsalable, was it a criticism? Was the boundary testing a delayed response to the repressive fifties? Was it seeded by the new government support for the arts available through the National Endowment and the various state art agencies? Was it stimulated by the so-called generation gap, by anger at the establishment, by the invention (or revival) of life styles predicated upon inventiveness, idealism, and risk?

My task here is not to document or analyze that particular part of the recent past, but to provide some notes toward an

Contact, 1969. Video sculpture including 6 cameras and 18 monitors, 90 x 90 x 42 in. Collection Fairleigh Dickenson University.

Iris, 1968. Video sculpture including 3 cameras and 6 monitors with clear Plexiglas bubble on front, 90 x 62 x 42 in. Collection Philadelphia Museum of Fine Arts.

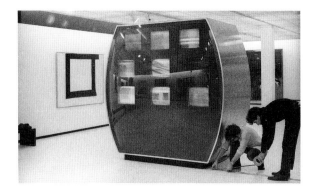

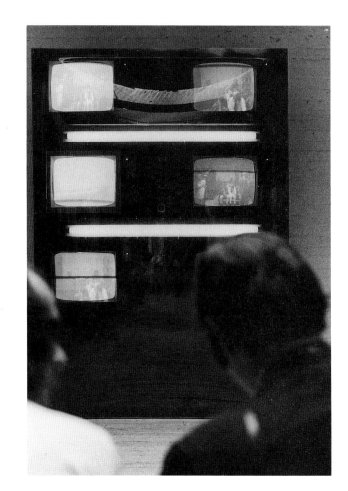

understanding of Les Levine's recent media art by revealing some of its roots. To my mind, his early work is an integral part of that time. Of course, his debut as an artist in New York in 1966 corresponded with my beginnings as an art critic. By 1968, I was enough enamored of his work to write the first art magazine article about him, "Plastic Man Strikes," which appeared in *ARTnews,* at that time still the influential art magazine in town, under the late Thomas Hess.

"Mild-mannered, soft-spoken Les Levine, wearing horn-rimmed glasses," I began, "steps into a telephone booth, orders a new plastic dome and almost everyone is infuriated." I went on to describe and interpret his "plastic disposable art" and his "epistemological environments." I stated that since Levine was obliterating the idea that art consisted of unique and

Bodyscape, 1971. One-hundred-and-fifty black-and-white photographs, 49 x 165 in. The entire 150 photographs make up an image of the artist's body.

precious objects, one might place him in a new category I labeled post-Modernism.

What was still passing for modernism at the time was critic Clement Greenberg's tidy version, which for all of its logic— each medium must be critical of itself, separate, and limited to its defining characteristic—was inordinately conservative. Somehow he managed to exclude Futurism, Constructivism, Dada, Surrealism, and all other critical strains from modern- ism. Instead, tasty paintings were presented as aesthetic transubstantiation. Through a rather easy congruence with the picture plane—a convention bordering on the theological—flat fields of color were to save the world from popular culture, pop art, and minimalism, while, perhaps not accidentally, saving the reputations and market-share of certain favored

Chain of Command, 1971. Video installation consisting of 3 ladders, a slide projector, a video camera, and 2 monitors. Installation at the Downtown Fischbach Gallery, New York.

Position, 1971-72. A performance installation consisting of shaped black-and-white photographs and various objects, including a ladder, a sheet of metal, 3 dictionaries, a toilet, a roll of canvas, 3 planks of wood, a piece of felt, a table, a taped-off square, and a bed. Installation at Downtown Fischbach Gallery, New York.

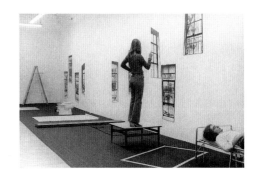

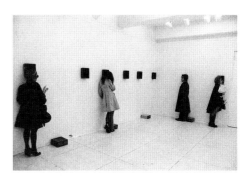

Wire Tap, 1970. Installation consisting of 12 speakers and 6 cassette tape players. Collection of National Gallery of Canada, Ottawa.

painters. Art, as was beginning to be common knowledge, was for the rich.

Even minimalism, anathema to the Greenbergians who should have embraced its objectness and apparently non-political purity, was, like Color Field painting, a consummate product. For a time—brief but generative—some of us would have no more of that. The world was falling apart. The dark side of the American Dream was belly-up and exposed: riots, assassinations, and a distant, unwinnable war brought home by television, campus sit-ins and marches in the streets. And art? For the most part, it seemed but a toy for those who directly or indirectly were profiting from Vietnam. Not all artists were silent. Some became directly political in their art, and others took direct aim at art itself.

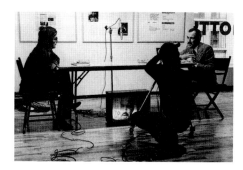

Museum of Mott Art, Inc., 1970. A conceptual museum invented by the artist.

Mott Art Hearings, 1971. A performance with closed circuit video. In this illustration, the artist is discussing art with the art critic Gregory Battcock (right).

A.I.R., 1970. Eighteen television sets connected to the artist's studio by microwave transmission. Installation for the *Software* exhibition at the Jewish Museum, New York.

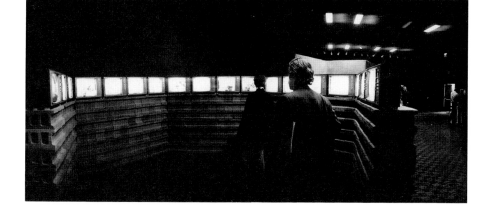

Les Levine was one artist, among a few others, who reexamined art and the art system by creating artworks that went against the grain. His "sculpture" was anti-monumental and required direct participation; his gallery shows made one doubt the gallery system; his press releases made one question the press release as a mode of communication; and when he made marketable artworks, not many people wanted them because they were unlimited edition disposables made out of plastic. His use of parody was brilliant: In 1972 he exhibited 18-carat gold castings of 30 sticks of gum he had chewed. "How much does it cost? I'll buy it!" proclaimed the press release.

In a 1974 catalogue essay for a survey of Levine's work at the Vancouver Art Gallery ("Language ÷ Emotion + Syntax =

Cosmetic Surgery, 1972. Altered photographs,
30 x 40 in. each.

Message") critic Jack Burnham indicates that

it was not until *The Troubles: An Artist's Document of Ulster*

at the Finch College Museum that the artist

pushed beyond satire and became serious. I maintain that

Levine was serious from the beginning. Satire was his tool.

II: I Remember Les

How did Les Levine and I become friends? This does not

usually happen between artists and poets. When critics—even

if they are also poets—write articles about artists, most often

the "friendship" stops. In the sixties, Levine seemed to

attract poets. His art reveals him to be a word person as well

as an eye person. The secret is that he talks like a poet or

remains silent like a poet. The language he uses (or does not

use) is poetic. He likes to play with words. Poets like that. In

many ways his art plays with media languages the way poets

The Last Book of Life, "Gold Cashew Nut," 1973.
Gold, chopsticks, and vitrine, 15 in. high x 10 in.
diameter. Installation at Documenta 6, Kassel,
1977.

The Last Book of Life, 1973. Mixed-media,
consisting of photographs, neon, gold nut, etc.
Installation at Stefanotty Gallery, 1974.

play with written or oral language.

Les was friendly with the younger poets: John Giorno, Ann

Waldman, Ted Greenwald, Larry Fagin and others. Poet-critic

Peter Schjeldahl beat me to Levine by writing about him first

in the *Village Voice.* I later became the art critic at that

august weekly when Schjeldahl moved on to the *Times* and

had a chance to make up for my laxness. Nevertheless, the

poetry-art connection, a New York School tradition descended

from Paris, was scrapped with the advent of Pop. Gerard

Malanga may have taught Andy Warhol how to silkscreen

images on canvas and Giorno may have starred in *Sleep*, but

no minimalists were seeking a Baudelaire or Apollinaire or

even a Frank O'Hara. They thought they could do their own

writing and presumed to know exactly what they were doing in

Northern Landscapes, 1974. Image of Les Levine
drawing in Cape Dorset.

Northern Landscapes, 1974. Image of Catherine
Levine and drawing by Les Levine in Cape Dorset.

their art. Poets were irrelevant. Levine, contrary to fashion,

had an affinity for poets.

I can't remember when I first met Mr. Levine. Was it at an art

gallery opening? Who introduced us? I think I met him through

his art. The *Star Machine*, a transparent, plastic walk-through,

was not like any art I had seen; it even altered the sound of

your own breathing.

I liked Levine almost immediately, perhaps because he is an

Irish-Jewish Canadian transplanted to New York. Like any good

poet, he has an outsider's point of view. He is also smart—too

smart to be an artist, one art dealer once whispered to me.

Some time after I met him, I remember going to his loft on the

Bowery for lunch. It had something to do with his newspaper

The Next 5 People, 1975. Twenty-five color photographs, 16 x 20 in. each, with document, 30 x 40 in.

The Next 5 People, 1975. Document, 30 x 40 in.

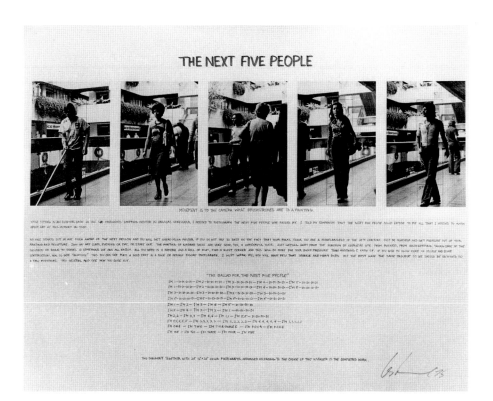

Culture Hero (the "Fanzine of the Superstars") and/or an

edition of poetry disposables he was producing for the

Museum of Modern Art Gift Shop. My poem was the one line,

"No one is drowning in the beautiful lake." Poems by a dozen

or so poets were molded in relief on pieces of transparent

plastic. And my name was misspelled.

Or was it one of his videotapes he had invited me to see? The

interviews with Bowery bums? No, that was earlier. It was

probably his willfully chaotic documentation of the Destruc-

tion Art Symposium with Lil Picard, Jean Toche, and Rafael

Ortez that was taped by a camera programmed to zoom and

pan automatically, no matter what was going on. Did the

dance critic Jill Johnston, who lived upstairs, come to lunch

also or was she dropping lit matches through the floorboards

109

We Are Still Alive, 1974. Photographs and videotape.
Installation at Galerie Gilles Gheerbrant, Montreal.

Range Finder, 1974. Two color photographs,
30 x 24 in. each.

to thank him for the special Jill Johnston issue of *Culture*

Hero? In any case, I remember that Levine served TV dinners,

which I thought was witty. It was like eating plastic food off

of one of his own disposables.

I also remember Les in a white vinyl Nehru jacket, looking like

a younger, more handsome Peter Sellers. Then a little later he

was wearing business drag. Now, of course, he has come to

look increasingly Irish with his shocking white hair.

In the sixties I thought it was wonderful that someone so

normal looking could come up with artworks that infuriated

almost everyone. The very idea that an artwork could be plas-

tic, could be disposable, could be an environment or

a situation or even an advertisement drove certain people

Chair for Mark Rothko, 1974. Four color photographs, 40 x 30 in. each. Collection Carol Johnssen, Munich.

crazy. I remember an otherwise civilized filmmaker threatening to punch me in the mouth because I had written about Levine.

I remember Les taking photographs of three naked poets in a steam bath—John Giorno, Ann Waldman, and myself. So that we would be comfortable, he was naked too. The photographs were for a poetry event poster. The world had already survived Living Theater nudity, Ann Halprin Dance Company nudity, Kusama street theater nudity, and Charlotte Moorman topless cello-playing nudity. We were simply standing there looking ridiculous. The poster was censored; the poetry event cancelled. Les made the poster his entry into a show he put together for the Architectural League called *My Worst Work*. He explained that it was his worst work because he had never been paid for it.

Bacon and Avocado, 1974.
Sixteen color photographs, 11 x 14 in. each.
Collection Dr. Louis Lambelet, Basel.

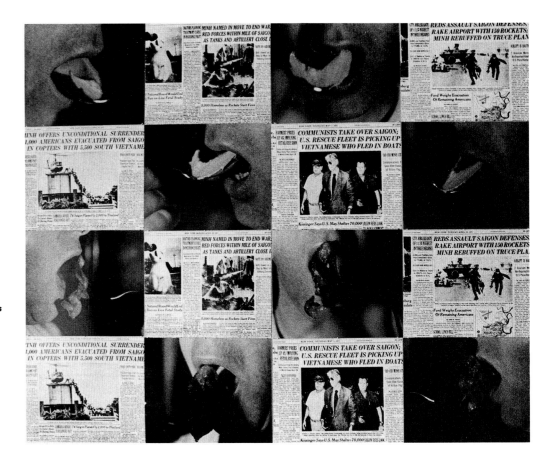

I remember Les on the phone and I remember Les flying here

and then there and having exhibitions and projects every-

where. I remember his artwork that consisted of the words *Les*

Levine Copies Everyone and in small type at the bottom, *Holly*

Solomon in Conversation with Lita Hornick. I remember a

piece he did called *Deep Gossip* and the only thing annoying

about it was you couldn't really hear the gossip very well.

I remember a great deal. But in general, like everyone else, I

remember less and less. The silly controversies and misunder-

standings fade. Certain artworks, however, stand out.

I remember *Plug Assist* from his first show at Fischbach:

vacuum-molded forms that looked like abstract refrigerators.

Even in pre-ecology days plastic was thought of as nonart and

Hand Work, 1974. Six color photographs, 14 x 11 in. each, with document.

tacky. But Les made plastic sensuous. The piece looked like shiny fabric stretched over solid forms, but it was only self-supporting skin.

I remember a piece called *Body Color* that used transparency, translucence, opaqueness and color to sculpt space as you walked through it. I remember Levine's Restaurant, featuring the only Irish-Jewish-Canadian cuisine in New York and the Miss Potato Latka contest. I remember *The Process of Elimination* and how Les littered a vacant lot with plastic forms and then gradually removed them, ten a day, until the lot was empty again. I remember *White Sight* that drained color from everyone and everything in the room. I remember *Electric Shock* (a charged wire strung across an empty gallery space). I remember the high-noise interrogation chamber of

What Can the Federal Government Do For You?
1975. Clothing with insignia, part of a multimedia
installation including large-screen video.

The Troubles: An Artist's Document of Ulster. I remember

more.

III: The Unanswered Questions

Les Levine has often described himself as a media sculptor.

By this he clearly does not mean he is to be defined simply as

a sculptor who appears on or in the media or whose work

does. Particularly at the beginning of his career in New York,

his work—not by accident—was often on the six o'clock news.

In the sixties art was news; Levine took advantage of this. As

well as being a video art pioneer, he was a broadcast televi-

sion pioneer, a publicity art pioneer. But the scope of his art

is larger.

By calling himself a media sculptor, Levine means that

newsprint, outdoor advertising, posters, television, radio—

What Can the Federal Government Do For You?
1975. Videotape, color, 30 mins.

What Can The Federal Government Do for You?
1975. Multimedia installation, including a large-screen video. Installation at M.L. D'Arc Gallery, New York, 1976.

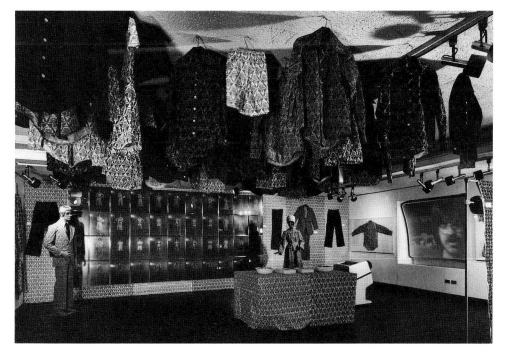

even gossip—and all other nonart forms of communication are his chosen metier. A painter's medium is pigment on canvas; a sculptor's is usually wood or metal or stone or clay; Levine's medium is the media. He is a media sculptor because he adds to or subtracts from the basic material—not matter exactly, but a mode or system of communication. His methods of sculpting include surprise, negation, inflection, ambiguity, overload, and humor; the better to reveal the material itself in much the same way a traditional sculptor reveals the qualities of wood, metal, stone, or clay (or any other material). Through an ongoing dialogue with communications media, Levine allows each medium its own voice. His interventions are homeopathic and intended to heal.

Certainly Levine's art exploits the devices of publicity,

Game Room, 1976. A multimedia installation, including pinball machines, soundtrack, and electronic message readers and video. Installation at M.L. D'Arc Gallery, New York, 1977. Collection Mrs. Johnssen, Essen.

Game Room, 1975. Videotape, color, 50 mins.

Starry Night, 1976. A multimedia installation including candles, photographs, food, and audio track. Installation at the National Gallery of Australia, Melbourne.

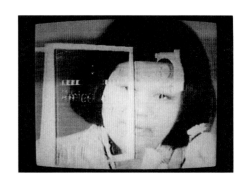

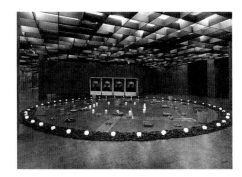

advertising and public relations, but the works are not about self-promotion, nor are they used to stimulate the purchase of art products or the creation of a mystique. If anything, Levine has been trying to de-mystify the role of the artist. Unlike Andy Warhol, who may have been less precise, more collective, and rather pathological in his use of media—and cleverly passive—Levine does not use media or allow media to use him to create a persona.

My thesis is that in the early work—work prior to the Times Square light board, the subway posters, and the billboard pieces which are the main subjects of this survey—Levine not only explored media through making artworks that could penetrate media, but also used this to reveal the art system as a medium in and of itself. This may be why so many found

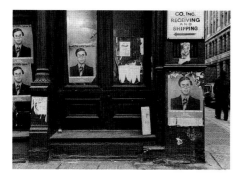

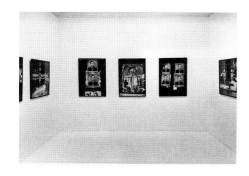

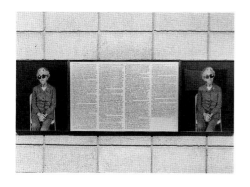

The Soho Poster Project, 1976.
Outdoor media campaign.

The Soho Poster Project, 1976. Outdoor media
campaign cibachrome documentations, 40 x 30 in.
each. Installation at Galerie de Gestlo, Hamburg.

I Am Not Blind: An Information Installation About
Unsighted People, 1976. Photographs, text and
video. Installation at Lions Gallery of the Senses,
Hartford.

his offerings offensive. By art system I mean the art galleries,
museums and non-profit spaces, and the full complement of
support subsystems such as journalism, art criticism, word-of-
mouth, and art collecting. At a certain point, he began to
sculpt the media more directly and perhaps the terms of
discourse were reversed. The media pieces were spun-off into
gallery works.

What then are we to make of the gallery objects and situa-
tions he created prior to his billboard sculptures? Is the *Star
Machine* ("everyone is a star!") a sculpture or is it an
occasion for photographs? My feeling is that if we were to
see this and other installation pieces again we would see
them more clearly as functional sculpture. The truth is that
Levine is a more complicated artist than I have as yet

Cornflakes, 1977. Video installation with cornflakes, slides, and jam. Installation at the Institute of Contemporary Art, Boston.

indicated. He may have attempted to dematerialize art, but the process produced beauty as well as information.

Has there ever been an artist so mercurial and difficult to categorize as Les Levine? Coming on the heels of pop and minimal art, he was by the late sixties neither post-pop nor post-minimal—it was far too early for these terms to apply. To some he combined the worst of each: the media-orientation and media-absorption of pop and the hands-off look and cerebral pretensions of minimalism. Too abstract for pop and too pop for the minimalists, he was also too sarcastic—and strangely humanist—for the doctrinaire conceptualists. In actuality, he was a post-conceptualist in the middle of a conceptual art period. He was making Smart Art before it was smart to do so.

I Am Not Blind: An Information Installation About Unsighted People, 1976. Videotape, color, 4 hrs.

Cornflakes, 1977. Videotape, color, 30 mins.

Now that deconstructive art, social action art, and neo-conceptualism have sprung to the fore, however briefly—art is long, but style is short (and recurring)—it is perhaps easier to put his early work in perspective. Levine was simply ahead of everyone else.

John Perreault, *Art Critic*

Past President International Association of Art Critics

Dimensions are given in inches and, except where noted, are listed in order of height and width.

Tired Earth, 1975
color photographs on wood, 4 panels, 82 x 102

Soho Poster Project, 1976
four cibachrome photographs, 40 x 30 each

The Cat Is on Her Shoulder, 1978
oil stick on canvas, 3 panels, 72 x 156

Take, 1978
oil stick on canvas, 78 x 96

Steal, 1978
oil stick on canvas, 78 x 96

Win, 1978
oil stick on canvas, 78 x 96

Pink Unconscious, 1979
color photographs on wood, 3 panels, 90 x 74

A Boy Making Sculpture, 1979
color photographs on wood, 3 panels, 90 x 74

Taking a Position, 1979
oil stick on canvas, 3 panels, 96 x 234

Taste Class, 1979
oil stick on canvas, 4 panels, 120 x 224

Toe the Line, 1979
oil stick on canvas, 3 panels, 108 x 132

We Are Not Afraid, 1979-81
offset lithography on card, 10 premium squares, 21 x 21 each

We Are Not Afraid, 1982
5 dyed photographs of subway poster in situ, 16 x 20 each

Mind, 1982
oil stick on canvas, 132 x 84

Selections from the Billboard Campaigns in Minneapolis (1982) and Los Angeles (1984)

Aim, 1982
paper billboard, 120 x 252

Race, 1982
paper billboard, 120 x 252

Aim (Minneapolis), 1982
watercolor, 29 x 37

Race (Minneapolis), 1982
watercolor, 29 x 37

Aim, Race, Take (Los Angeles), 1984
watercolor, 29 x 37

Steal, Forget (Los Angeles), 1984
watercolor, 29 x 37

Take (Los Angeles), 1984
colored pencil drawing, 30 x 20
Collection Horst Schmitter, Frankfurt

Aim (Los Angeles), 1984
colored pencil drawing, 30 x 20
Collection Reto Fehr, Stansto, Switzerland

Forget (Minneapolis), 1982
colored pencil drawing, 30 x 20
Collection Leo Waltenspuhl, Hergiswil, Switzerland

Race (Minneapolis), 1982
colored pencil drawing, 30 x 20
Courtesy Mai 36 Galerie, Lucerne

Selections from the Billboard Campaign at the Institute of Contemporary Arts, London (1985)

Hate God, 1985
paper billboard, 120 x 252

Blast God, 1985
paper billboard, 120 x 252

Kill God, Block God, 1985
watercolor, 29½ x 37

Attack God, 1985
watercolor, 29½ x 37

Attack God, 1988
computer-scanned laser-jet painting, 72 x 120
Courtesy Mai 36 Galerie, Lucerne

Selections from the Billboard Campaign in Staten Island (1986)

Every Child/Can Do! 1986
watercolor, 22 x 31

Every Child/Aim High, 1986
watercolor, 22 x 31

Selections from the Billboard Campaign for Documenta 8, Kassel, West Germany (1987)

Forgive Yourself, 1987
paper billboard, 120 x 252

Master Yourself, 1987
paper billboard, 120 x 252

Exploit Yourself, Charm Yourself, Sell Yourself, Seduce Yourself, 1987
paper billboard, 120 x 252

Master Yourself, 1987
watercolor, 29½ x 37

Exploit Yourself, Seduce Yourself, 1987
watercolor, 29½ x 37

Create Yourself, 1987
watercolor, 29½ x 37

Hate Yourself, 1988
computer-scanned laser-jet painting, 78 x 120

Create Yourself, 1988
computer-scanned laser-jet painting, 78 x 120

Create Yourself, 1988
computer-scanned laser-jet painting, 72 x 120
Courtesy Mai 36 Galerie, Lucerne

Aim, Defeat, Consume, Leave, 1987
oil stick on canvas, 68 x 121¼

Torture, Control, Play, Forget, 1987
oil stick on canvas, 68 x 114¼

Selections from the Billboard Campaign in Dijon (1988)

Feed Greed, 1988
paper billboard, 120 x 144

Pray for More, 1988
paper billboard, 120 x 144

Selections from the Billboard Campaign in Frankfurt (1989)

Switch Position, 1989
paper billboard, 120 x 144

Get More, 1989
paper billboard, 120 x 144

Draw Charm, 1989
computer-scanned laser-jet painting, 74 x 114½

Draw Charm/Bi, 1989
watercolor, 26 x 41
Courtesy Mai 36 Galerie, Lucerne

Get More/Test the West, 1989
watercolor, 26 x 41
Courtesy Galerie Brigitte March, Stuttgart

Selections from the Billboard Campaign in Stuttgart (1988)

Pray for More, 1988
computer-scanned laser-jet painting, 75 x 114½

Pray for More/Das Echte, 1989
watercolor, 22 x 30

Feed Greed/Camel, 1989
watercolor, 22 x 30

Selections from the Billboard Campaign in Dortmund (1989)

Green House, 1989
paper billboard, 120 x 144

Control Arms, 1989
paper billboard, 120 x 144
Courtesy Galerie Brigitte March, Stuttgart

Control Arms, 1989
computer-scanned laser-jet painting, 73 x 114

Selections from the New York Subway Project (1989)

Consume or Perish and *Pray for More*, 1989
offset lithography on card, 10 premium squares,
21 x 21 each

Consume or Perish and *Pray for More*, 1989
6 cibachrome photographs, 16 x 20 each

Consume or Perish, 1989
computer-scanned laser-jet painting, 64½ x 72

Pray for More, Portrait of Les Levine, 1990
computer-scanned laser-jet painting, 71 x 62

Feel Time, 1990
watercolor, 26 x 41
Collection Brigitte François, Hergiswil, Switzerland

Not Guilty, 1990
watercolor, 26 x 41
Courtesy Mai 36 Galerie, Lucerne

Imitate Touch, 1990
watercolor, 26 x 41
Courtesy Mai 36 Galerie, Lucerne

Change Your Mind, 1990
watercolor, 26 x 41
Courtesy Mai 36 Galerie, Lucerne

Power Play, 1990
watercolor, 26 x 41
Courtesy Mai 36 Galerie, Lucerne

A New Billboard Campaign for Syracuse (1990)

Imitate Touch, 1990
paper billboard, 120 x 252

Green House, 1990
paper billboard, 120 x 252

Not Guilty, 1990
paper billboard, 120 x 252

A Selection Of Videos

Bum, 1965, b/w, 50 mins.

The Last Sculpture Show, 1971, color, 25 mins.

Artistic, 1974, color, 30 mins.

Les Levine's Greatest Hits, 1974, color, 30 mins.

Brainwash, 1974, color, 30 mins.

I Am An Artist, 1975, color, 30 mins.

We Are Still Alive, 1975, color, 50 mins.

Landscape II, 1975, color, 30 mins.

Landscape III, 1975, color, 30 mins.

What Can the Federal Government Do for You? 1975,
color, 30 mins.

I Am Not Blind, 1976, color, 4 hrs.

Disposable Monument, 1976, 17 spots, 30 secs. each

Diamond Mind, 1977, color, 30 mins.

House of Gloves, 1978, color, 5 mins.

Visions from the God World (Parts I-V), 1981,
color, 31 mins. each

Einstein: A Nuclear Comedy, 1983, color, 22 mins.

Performance 70s, 1971-1983, color, 1 hr.

Anxiety, Religion and Art, 1985, color, 22 mins.

Media Mass, 1985, color, 8 mins.

Close Frenzies, 1986, color, 26 mins.

Books and portions of books

1968 *New Art USA*. Munich: Das Modern Art Museum.

Battcock, Gregory, ed. *Minimal Art: A Critical Anthology*. New York: E.P. Dutton, pp. 368-69.

Burnham, Jack. *Beyond Modern Sculpture*. London: Penguin Press, pp. 365-66.

1969 Levine, Les. *Poem Disposable*. New York: The Museum of Modern Art.

1971 Burnham, Jack. *The Structure of Art*. New York: Braziller, pp. 39, 47, 146-47.

Calas, Nicholas, and Elena Calas. *Icons and Images of the Sixties*. New York: E.P. Dutton, pp. 312-14, 318, 335.

1973 Battcock, Gregory. *Idea Art*. New York: E.P. Dutton, pp. 194-203.

Lippard, Lucy. *Six Years: The Dematerialization of the Art Object*. New York: Praeger, pp. 74-75.

1974 Burnham, Jack. *Great Western Salt Works*. New York: Braziller, pp. 39-46.

Levine, Les. *Camera Art*. Wayne, NJ: Ben Shahn Art Gallery at William Paterson College.

1976 Levine, Les. *Using the Camera As a Club/Not Necessarily a Great One*. New York: Museum of Mott Art.

1977 Kardon, Janet. *Time*. Philadelphia: Philadelphia College of Art, pp. 12-13.

1979 Levine, Les. *MEDIA: The Bio-Tech Rehearsal for Leaving the Body*. Alberta: Alberta College of Art Gallery.

Petruck, Peninah, ed. *The Camera Viewed: Writings on Twentieth-Century Photography*, vol. 2. New York: E.P. Dutton, pp. 129-35.

1982 Rovner, A., et al. *The Gnosis Anthology of Contemporary American and Russian Literature and Art*, vol. 2. New York: Gnosis Press, p. 116.

1983 *The Catalog of American Drawings, Watercolors, Pastels and Collages*. Washington, DC: Corcoran Gallery of Art.

Grueber, Bettina, and Maria Vedder. *Kunst und Video*. Cologne: DuMont Buchverlag, pp. 164-67.

1984 Battcock, Gregory, and Robert Nickas, eds. *The Art of Performance A Critical Anthology*. New York: E.P. Dutton, pp. 25-54.

1985 Schwartzman, Allan. *Street Art*. Garden City, NY: Dial Press, p. 69.

1986 Goodman, Cynthia. *Digital Visions: Computers and Art*. New York: Harry N. Abrams and Everson Museum of Art, pp. 92-93.

1989 Lovejoy, Margot. *Postmodern Currents*. Ann Arbor: UMI Research Press, pp. 92-111, 181.

One-Person Exhibitions

1964 David Mirvish Gallery, Toronto

1965 Isaacs Gallery, Toronto

1966 Fischbach Gallery, New York
Art Gallery of Ontario, Toronto
Art Gallery, School of Visual Arts, New York

1967 Fischbach Gallery, New York
The Walker Art Center, Minneapolis
The Museum of Modern Art, New York
Architectural League of New York
Finch College Museum of Art, New York

1968 Fischbach Gallery, New York
Architectural League of New York
Gibson Gallery, New York

1969 *Levine's Restaurant*, 19th Street and Park Avenue South, New York
————, *Jack Burnham to Wed Judith Benjamin*
Le Prix Levine à la Sixième Biennale de Paris, Paris
Museum of Contemporary Art, Chicago
Phyllis Kind Gallery, Chicago
Loeb Student Center, New York University, New York
Museum of Contemporary Art, Chicago

1970 Isaacs Gallery, Toronto
Fischbach Gallery, New York

1971 Galerie M.E. Thelen, Cologne
Protetch-Rivkin Gallery, Washington, DC
WETA, Public Television, Washington, DC

1972 Fischbach Gallery, New York

1972- Finch College Museum of Art, New York
1973 Fischbach Gallery, New York

1973 The Vancouver Art Gallery, British Columbia
Isaacs Gallery, Toronto
Molly Barnes Gallery, Los Angeles
Anna Leonowens Gallery, Nova Scotia College of Art and Design, Halifax

The Michael C. Rockefeller Art Gallery, State University of New York at Fredonia

1974 Vancouver Art Gallery, British Columbia, *Language÷Emotion + Syntax = Message* (exhibition catalogue)
Galerie Gerald Piltzer, Paris
Galleria Schema, Florence
Miami-Dade Community College, Miami
Stefanotty Gallery, New York, *The Les Levine Group Show*
Musée d'Art Moderne de la Ville de Paris

1975 São Paulo Biennial, Brazil
Channel J, Manhattan Cable, *Cable Arts Les Levine Festival*
A Space, Toronto
Adler Castillo, Caracas, Venezuela

1976 Wadsworth Atheneum, Hartford, Connecticut
M.L. D'Arc Gallery, New York
University of California, Los Angeles
National Gallery of Victoria, Melbourne

1977 Everson Museum of Art, Syracuse
Albright-Knox Art Gallery, Buffalo
Isaacs Gallery, Toronto
Channel 31 Television, New York
Galerie Arnesen, Copenhagen
M.L. D'Arc Gallery, New York
AIR/ZBS Foundation, Fort Edward, New York

1978 International Cultural Center, Antwerp, *Les Levine: Diamond Mind*
Rotterdamse Kunststichting, Rotterdam
Synapse Video Center, Syracuse

1979 Canadian Cultural Centre, Paris
Ronald Feldman Gallery, New York
Holly Solomon Gallery, New York
Galerie Jollenbeck, Cologne, *Les Levine: Media Installation, Fotos, Videotapes*
Myers Fine Arts Gallery, State University of New York at Plattsburgh
Philadelphia Museum of Art

1980 Marian Goodman Gallery, New York, *Ads*
————, *More Ads*
Ronald Feldman Gallery, New York
The Enzo Cannaviello Gallery, Milan, *Billboards and Media Projects*
Wollman Auditorium, New York

1981 Ronald Feldman Fine Arts, New York, *Country Billboards: A Tribute to the Pioneering Spirit of America*
Galerie Jollenbeck, Cologne, *Pictures and Atmospheres Since 1971*

1982 Galleria del Cavallino, Venice, *Visions from the God World*

1983 Kunstlerhaus, Stuttgart
N.A.M.E. Gallery, Chicago, *New Mass Media Projects*
Fashion Moda, New York
Ronald Feldman Fine Arts, New York, *New Media Projects*
Honolulu Academy of Art, *Visions From the God World*
Channel J, SOHO Television, New York, *The Live Television Show*

1984 Los Angeles Institute of Contemporary Art, *New Media Projects: Billboards*
Ted Greenwald Gallery, New York, *Drawings Models Polaroids*

1985 Spectacolor light board, One Times Square, New York
Institute of Contemporary Arts, London (exhibition catalogue)
Orchard Gallery, Londonderry, Northern Ireland

1986 Carpenter + Hochman, New York, *Giant Computer Assisted Drawings*
Douglas Hyde Gallery, Trinity College, Dublin
Ted Greenwald Gallery, New York, *3 by Les Levine*

1987 Elizabeth Galasso Fine Art, Ossining, New York, *Advertise Yourself*

1988 Mai 36 Galerie, Lucerne, *Media Projects and Public Advertisements*
Symmetry '88, Middleburg, Holland

1989 Art Frankfurt, Kunstmesse Frankfurt
International Center of Photography, New York, *Les Levine's Video: A Selection from Two Decades*
La Galerie de Poche, Paris
New York Foundation for the Arts, New York City Subways

1990 Galerie Montaigne, Paris (exhibition catalogue)
Mai 36 Galerie, Lucerne
Centraal Museum, Utrecht, Holland

Group Exhibitions

1963 David Mirvish Gallery, Toronto, *Exhibition 8*

1964 Albright-Knox Art Gallery, Buffalo
National Gallery of Canada, Ottawa, *Second Canadian Sculpture Exhibition*

1965 National Gallery of Canada, Ottawa, *6th Biennial of Canadian Sculpture*

1966 The Museum of Modern Art, New York, *The Object Transformed* (exhibition catalogue)

1967 Institute of Contemporary Art, Boston, *Nine Canadians*
_____, *The Projected Image*
Montreal, Canada, Expo '67, Federal Pavilion
The Museum of Modern Art, New York, *Dada, Surrealism & Today*

1968 Whitney Museum of American Art, New York, *New Acquisitions*
_____, *Artists Under 40*
The Museum of Modern Art, New York, *Intermedia '68*
Finch College Museum of Art, New York, *Destructionists*
Fondation Maeght, Saint-Paul-de-Vence, France
Architectural League of New York, *Television Series*
University Museum, Mexico City
San Antonio, Texas, Hemisfair '68

1969 Rose Art Museum, Brandeis University, Waltham, Massachusetts, *Vision & Television*
The Jewish Museum, New York, *Plastic Presence* (travelled)
São Paulo Biennial, Brazil
The Institute of Contemporary Art, University of Pennsylvania, Philadelphia, *Between Object and Event* (exhibition catalogue)
Albright-Knox Art Gallery, Buffalo, *Manufactured Art*
Whitney Museum of American Art, New York, *Sculpture Annual*

1970 Institute of Contemporary Arts, London, *Multiple Art*
The Jewish Museum, New York, *Software Show*
The Museum of Modern Art, New York, *Information Show* (exhibition catalogue)
Art Gallery of Ontario, Toronto, *Sensory Perception*

1971 Galerie M.E. Thelen, Cologne
Architectural League of New York
National Gallery of Canada, Ottawa, *Conceptual Decorative* (exhibition catalogue, travelled)

1973 Edinboro State College, Edinboro, Pennsylvania, *The Instruction Show*

1974 Cologne, West Germany, *Projekt '74*
Tokyo, Japan, *Bienniale of Prints*
The Clocktower, New York, *Words/Discussions*
Art Gallery of Ontario, Toronto, *Videoscape*

1975 The Clocktower, New York, *Artists Make Toys*
Institute of Contemporary Art, University of Pennsylvania, Philadelphia, *Video and Television*
Hayden Art Gallery, Massachusetts Institute of Technology, Cambridge, *Art Transition*
The Museum of Modern Art, New York, *Projects Video V*
Anthology Film Archives, New York

1976 Museum of Fine Arts, Boston, *Changing Channels* (exhibition catalogue)
Whitney Museum of American Art, Downtown Branch, New York, *Art: World* (exhibition catalogue)
Milwaukee Art Center, *For Foreign Shores: Three Centuries of Art by Foreign Born American Masters* (exhibition catalogue)
The Jam Factory, Adelaide, Australia
Galerie Gilles Gherrbrant, Montreal
Gallery of New South Wales, Sydney, Australia, *1976 Biennale*
Capricorn Asunder Gallery, San Francisco, *Video October*
Cable Art Foundation, New York, *Video Gallery I, II, III*
Museum and Nature Center, Stamford, Connecticut, *American Salon des Refusés*

1977 Whitney Museum of American Art, Downtown Branch, New York, *Words*
Zurich Kunsthalle, *Art in the Age of Photography*
University Art Museum, University of California, Berkley, *Commissioned Videos*
Documenta 6, Kassel, West Germany (exhibition catalogue)
Creighton University, Omaha, Nebraska, *Video Art*

1978 Philadelphia Art Alliance, *Science in Art*
The Museum of Modern Art, New York, *Projects*
_____, *Gold*
Neuberger Museum, State University of New York at Purchase, *The Sense of Self*
Institute of Contemporary Art, Boston, *Wit and Wisdom: Works by Baldessari, Hudson, Levine, and Oppenheim*
Los Angeles County Museum of Art, *Primitive Images*
Museum of Contemporary Crafts of the American Crafts Council, New York, *The Great American Foot*

1979 Musée National d'Art Moderne, Centre National d'Art et de Culture Georges Pompidou, Paris, *Journées Interdisciplinaires sur l'Art Corporel et Performances* (exhibition catalogue)
Marian Goodman Gallery, New York, *Group Show with a Smile*
Alberta College of Art Gallery, Calgary, *Sense of Self: From Self-portrait to Autobiography*
Everson Museum of Art, Syracuse, *Everson Video Revue 1978-79* (travelled)
Art Institute, San Francisco
International Cultural Centre, Antwerp, *Biennial Exhibition of the Association Belge des Critiques d'Art* (exhibition catalogue)
Palazzo Pucale/Bochum, Museum Bochum, Genova, Italy

1980 The Museum of Modern Art, New York, *Printed Art, A View of Two Decades* (exhibition catalogue)
Anthology Film Archives, New York, *TV Tactics*
Gowanus Memorial Art Yard, Brooklyn, *The Monumental Show*
Everson Museum of Art, Syracuse, *Everson Video Revue*
Whitney Museum of American Art, New York, *Printed Art Show*
CAPS Travelling Video Festival, New York
Venice, Italy, *XXXIX Biennale di Venezia*
The National Video Clearinghouse, Inc., Syosset, New York, *1980 VIDI Award: Most Unusual Video Program of the Year*

1981 Stedelijk Museum, Amsterdam, *Instant Photography*
Neuberger Museum, State University of New York at Purchase, *Soundings* (exhibition catalogue)
Visual Studies Workshop, Rochester, *From the Academy to the Avant-Garde* (exhibition catalogue, travelled)
Des Refuses, Westbeth, New York, *Monumental in Manhattan*
Pratt Manhattan Center Gallery, New York, *The Destroyed Print*
Gracie Mansion Gallery, New York, *Famous*
London Regional Art Gallery, Ontario, *Video Tapes by Video Artists*

1982 Art Gallery of Ontario, Toronto, *New Narratives for Living Room Viewing*
Studio Trisorio, Naples, Italy, *Differenza Video*
San Francisco International Video Festival
Le Cinema Parallele, Montreal, *Presence-Video*

Muzeum Sztuki, Lodz, Poland, *Exchange Between Artists, An Experience for Museums*
Akademie der Kunste, Berlin, *OKanada*
Real Art Ways, Hartford, Connecticut

1983 Douglas Hyde Gallery, Trinity College, Dublin, *Exchange Between Artists, 1931-1981, Poland-USA*
Glendon Gallery, Toronto, *Documentary Video*
Institute of Contemporary Art, Boston, *Ten Years of Video—The Greatest Hits of the 70s*
University Community Video, University of Minnesota, Minneapolis
Minneapolis College of Art & Design Gallery, *World Works*
Anthology Film Archives, New York
Video Free America, San Francisco
The Museum of Modern Art, New York, *Video Art: A History*
The Brooklyn Museum, *The American Artist as Printmaker*
San Francisco International Video Festival
High Museum of Art, Atlanta, *Seventh Atlanta Independent Film and Video Festival*

1984 New England Foundation for the Arts, Cambridge, Massachusetts, *Offset: A Survey of Artists' Books*
Summit Art Center, Summit, New Jersey, *Connections: Science into Art*
Area, New York, *Artventure*
Dance on the Lower East Side, New York
Hirshhorn Museum and Sculpture Garden, Washington, DC, *Content: A Contemporary Focus, 1974-1984* (exhibition catalogue)
Stedelijk Museum, Amsterdam, *Aerogramme—Mail Art Show*
Museum School Gallery, School of the Museum of Fine Arts, Boston, *Twelve on 20 x 24*
Centro di Documentazione Sezione di Comunicazione Visiva, Milan, *Television Art Dallo Skyline Americano*
The Museum of Modern Art, New York, *Ten Years of Contemporary Art*

1985 The Hudson River Museum, Yonkers, New York, *A New Beginning 1968-1978*
Gallery 360°, Tokyo, *Objects Box*
Musée National d'Art Moderne, Centre National d'Art et de Culture Georges Pompidou, Paris, *Artists' Books*
Hillwood Art Gallery, Long Island University, C.W. Post Campus, Greenvale, New York, *The Doll Show:*

Artist's Dolls and Figurines
Visual Studies Workshop, Rochester, New York, *NO-TV*
Millennium, New York
Kunsthaus Hamburg and Kunstverein in Hamburg, *Biennale des Friedens*

1986 The Queens Museum, Flushing, New York, *The Real Big Picture*
Newhouse Gallery, Snug Harbor Cultural Center, Staten Island, New York, *Eminent Immigrants*
Indianapolis Museum of Art, *Painting and Sculpture Today*
Academie der Kunst, Copenhagen
The Freeman Gallery, Albright College, Reading, Pennsylvania, *Twelve on 20 x 24*
Long Beach Museum of Art, California, *Documentary Video: Decades of Change*

1987 Documenta 8, Kassel, West Germany
Los Angeles County Art Museum, *Photography and Art*
Everson Museum of Art, Syracuse, *Computers and Art*
Hillwood Art Gallery, Long Island University, C.W. Post Campus, Greenvale, New York, *Perverted by Language*
John and Mable Ringling Museum of Art, Sarasota, *This Is Not a Photograph*

1987- Akron Art Museum, Ohio, *This Is Not a Photograph*
1988 Museum of Art, Fort Lauderdale, Photography and Art

1988 The Museum of Modern Art, New York, *Committed to Print* (exhibition catalogue)
_____, *American Documentary Video* (travelled)
The Queens Museum, Flushing, New York, *Photography and Art*
_____, *New York Film and Video Series*
Museum Ludwig, Cologne, *Marcel Duchamp und die Avantgarde seit 1950*
IBM Gallery of Science and Art, New York, *Computers and Art*
Newhouse Gallery, Snug Harbor Cultural Center, Staten Island, New York, *The Transformative Vision*
Lehman College Art Gallery, Bronx, *The Turning Point: Art and Politics in 1968*

1988- Stalke Galleri, Copenhagen, *Concept Art*
1989 The Museum of Modern Art, New York, American Documentary Video

1989 The Peace Museum, Chicago, *Committed to Print*
Kolnischer Kunstverein, Cologne, *Video-Skulptur*
La Galerie de Poche, Paris, *American Rainbow*
Brigitte March Galerie, Stuttgart, *Concept Art*

Museum am Ostwall, Dortmund, *In Other Words* (exhibition catalogue)

Whitney Museum of American Art, New York, *Image World* (exhibition catalogue)

Articles in periodicals

1967 Ashberry, John. "Les Levine." *ARTnews*, December, p.17.

Kozloff, Max. "Les Levine, Fischbach Gallery." *Artforum*, January, pp. 56-57.

Tabachnick, Anne. "Slipcover." *ARTnews*, summer, p. 23.

1968 Burnham, Jack. "Systems Esthetics." *Artforum*, September, pp. 30-35.

David, Douglas. "Art and Technology—The New Combine." *Art in America*, January-February, pp. 29-37.

Perreault, John. "Plastic Man Strikes." *ARTnews*, March, pp. 36, 71-73.

1969 Bourdon, David. "Plastic Man Meets Plastic Man." *New York Magazine*, February 10, pp. 44-46.

Burnham, Jack. "Real Time System." *Artforum*, September, pp. 49-55.

Burton, Scott. "Fischbach Gallery." *ARTnews*, March, p. 21.

Margolies, John. "T.V. The Next Medium." *Art in America*, September-October, pp. 86-93.

Newman, Thelma. "The Artist Speaks: Les Levine." *Art in America*, November - December, pp. 86-93.

Ortman, George. "Artists' Games." *Art in America*, November-December, pp. 69-77.

1970 Burnham, Jack. "Les Levine—Business as Usual." *Artforum*, April, pp. 40-43.

1971 "Information Fallout." *Studio International*, April, pp. 264-67.

1972 Perreault, John. "Textures of an Irish Disaster." *Village Voice*, December 28.

Levine, Les. "Weekend in Belfast: A Carpet of Broken Glass." *Village Voice*, December 28, p. 18.

1973 Burnham, Jack. "Les Levine and *The Troubles*." *Arts*, April, pp. 56-59.

Levine, Les. "It's Realistic But Is It Art." *Saturday Review*, February, pp. 18.

_____. "The Best Art School in North America?" *Art in America*, July-August, p. 15.

Stitelman, Paul. "The Troubles: An Artist's Document of Ulster." *Arts*, February, p. 70.

1974 Levine, Les. "The New Deal." *Arts*, January, pp. 42-51.

_____. "He Hobnobs in Russia." *Flash Art*, December, pp. 6-10.

1975 Levine, Les. "The Social Histories of Art—Dateline Arctic." *Art in America*, May-June, pp. 30-31.

_____. "Camera Art." *Studio International*, July-August, pp. 52-54.

Perreault, John. "The Les Levine Group Show." *Art in America*, March, pp. 85-86.

1976 Andre, Michael. "What Can the Federal Government Do For You?" *ARTnews*, May, p. 121.

1977 Kurtz, Bruce. "Artist's Video at the Crossroads. "*Art in America*, January-February, pp. 36-40.

Perlberg, Deborah. "Video from Out-side." *Artforum*, March, p. 71.

Ratcliff, Carter. "Issue and Commentary—the American Artist from Loner to Lobbyist." *Art in America*, March-April, pp. 10-12.

1978 Cavaliere, Barbara. "Les Levine: MOMA." *Arts Magazine*, December, pp. 22-24.

1979 "Eat Their Feet." *ARTnews*, April, pp. 19-20.

"Les Levine: Paysages du Grand Nord." *Centre Culturel Canadien Bulletin d'Information*, April.

1980 Cavaliere, Barbara. "Les Levine." *Arts Magazine*, February, p. 9.

Rice, Shelly. "ADS." *Artforum*, March, pp. 76-77.

1981 Frank, Peter. "Artists Go on Record: The Next Song You Hear on the Radio Might Well Be Art." *ARTnews*, pp. 74-76.

1982 Liebmann, Lisa. "Les Levine." *Artforum*, October, pp. 69-70.

1984 Atkins, Robert. "Einstein: A Nuclear Comedy." *Artforum*, February, p. 85.

Thomson, Patricia. "Atomic Reactions." *Afterimage*, April, p. 9.

Zimmer, William. "Les Levine at Ted Greenwald." *Arts Magazine*, November, p. 20.

1985 Galasso, Elizabeth. "Les Is More." *East Village Eye*.

Henry, Gerrit. "Les Levine at Ted Greenwald." *ARTnews*, March, pp. 147-49.

Hoberman, John. "Les Levine, Millennium Film Workshop." *Artforum*, summer, p. 107.

Howell, John. "Les Levine at Ted Greenwald." *Artforum*, February, p. 87.

Levine, Les. "The Government Wants to Destroy Art." *Art and Artists*, May-June, p. 11.

Smith, Roberta. "Endless Meaning at the Hirshhorn." *Artforum*, April, pp. 81-85.

1986 Westfall, Stephen. "Les Levine at Carpenter and Hochman." *Art in America*, November, p. 163.

1987 Braff, Phyllis. "Language Becomes the Medium of the Message." *The New York Times*, March 1.

Haden-Guest, Anthony. "The Art of Musical Chairs." *Vanity Fair*, September, pp. 60-72.

Liebmann, Lisa. "Things That Go Bump." *Artforum*, October, pp. 100-106.

Steinberg, Janice. "Boards Put Issues, Artists Out Front." *Advertising Age*, June, p. 48.

1988 Perreault, John. "Sleeper Awake?" *Village Voice*, December 13, p. 113.

Princenthal, Nancy. "Political Prints: An Opinion Poll." *The Print Collector's Newsletter*, May-June, pp. 44-47.

Steinberg, Janice. "When Artists Advertise." *High Performance*, fall, pp. 42-45.

Zimmer, William. "A Potent Look Back at 1968: A Visual Memory of Social Change." *The New York Times*, November 27.

1989 Atkins, Robert. "New York." *Contemporanea*, November, pp. 36-37.

Barasch, Amy. "Les Levine—Subway Project." *7 Days*, October 4, p. 68.

Nemeczek, Alfred. "Video-ans einer Marotte wird Kunst." *Art das Kunstmagazin*, March, pp. 60-66.

Perreault, John. "Through a Glass Darkly." *Artforum*, March, pp. 106-112.

Posca, Claudia. "In Other World." *Kunstforum*, November-December, pp. 364-65.

Uckermann, Frances. "New York Portraits." *Artis*, March, pp. 24-29.

1990 "Les Levine—The Word is God." *Kanal Magazine*, March, pp. 46-48.

Heartney, Eleanor. "Memory Traces." *Art and Auction*, March, pp. 184-89.

Levine, Les. "Off the Road." *Two and Two*, March-April, p.23.

Selected collections

The National Gallery of Australia, Canberra

Whitney Museum of American Art, New York

Best Products, Richmond, Virginia

New Orleans Museum of Art

Philadelphia Museum of Art

Institute of Contemporary Art, Boston

The Corcoran Gallery of Art, Washington, DC

The Metropolitan Museum of Art, New York
Art Gallery of Ontario, Toronto
Museum of Modern Art, New York
Honolulu Academy of Art
Museum on Fine Arts, Boston
National Museum of American Art, Smithsonian Institution, Washington, DC
Indianapolis Museum of Art
Museum of Contemporary Art, Los Angeles

Videotapes produced by Les Levine since 1965

1965 *Bum,* b/w, 50 mins.

1966 *Critic,* b/w, 30 mins.
The Nude Model, b/w, 1 hr.

1967 *Destruction in Art,* b/w, 2 hrs.
Clothing and the Law, b/w, 1 hr.
Architecture, b/w, 1 hr.

1968 *The London Scene,* b/w, 22 mins.
The Dealer, b/w, 33 mins.
Blank, b/w, 1hr.

1969 *John & Mimi's Book of Love,* b/w, 50 mins.
Columbia, b/w, 1 hr.
Fashion Show Poetry Event, b/w, 40 mins.
Paint, color, 7 mins.

1970 *Topesthesia I,* b/w, 30 mins.
Mott Art Hearings, NY, b/w, 5 hrs.
Mott Art Hearings, b/w, 1 hr.

1971 *The Last Sculpture Show,* color, 25 mins.
Landscape I, color, 30 mins.

1971- *Performance 70'S,* color, 1 hr.
1983

1972 *The Troubles: An Artist's Document of Ulster,* color, 55 mins.
Stand-up Cop, b/w, 2 hrs.
Gilbert and George, color, 7 mins.
Christmas Card, color, 10 mins.
Outside the Republican Convention, color, 25 mins.
Space Walk, color, 30 mins.
The Killing of the Father, color, 30 mins.
Mrs. Hunt, color, 15 mins.

1973 *The Ritual,* color, 31 mins.
Supervision–Object, AV tape A, b/w, 1 hr.
Supervision–Subject, AV tape B, b/w, 1 hr.
The Day of the Jackal as Taken by Les Levine, b/w, 40 mins.
The Last Book of Life, segments 1 and 2, color, 1 hr.
Topesthesia II, color, 21 mins.

1974 *Language + Emotion + Syntax = Message,* b/w, 20 mins.
Suicide Sutra, color, 30 mins.
Artistic, color, 30 mins.
Les Levine's Greatest Hits, color, 30 mins.
The Story of Three Children, b/w, 30 mins.
Spaghetti, color, 30 mins.
Les Levine's Firenze, b/w, 30 mins.
Dinner with Brion, b/w, 1 hr.
Chili Concarne, color, 1 hr.
Mott Art Hearings, b/w, 1 hr.
Mott Art Hearings, NYC, 6th edition, b/w, 1 hr.
Art Interactions I, b/w, 1 hr.
Art Interactions II, b/w, 1 hr.
Visiting Artist, color, 30 mins.
If I Graduate, color, 30 mins.
Old Master, color, 30 mins.
A Portrait of Les Levine, color, 30 mins.
A Portrait of Anna, color, 30 mins.
Watergate Au Revoir, color, 1 hr.
Brainwash, color, 30 mins.
I Am an Artist, color, 30 mins.

1975 *We Are Still Alive,* color, 50 mins.
A Interview with Bob Mulholland, color, 30 mins
Magic Carpet, color, 30 mins.
Landscape II, color, 30 mins.
Landscape III, color, 30 mins.
Kalu Rinpoche, color, 25 mins.
Fortune Cookie, color, 30 mins.
Cheap Thrill, color, 30 mins.
One Gun, color, 30 mins.
What Can the Federal Government Do For You? color, 30 mins.
Federal Fashions, color, 30 mins.
Video Lecture, color, 1 hr.
Starry Night, color, 30 mins.
Mr. Abstract, color, 30 mins.
The Last Art Student Has Been Eaten, color, 30 mins.

1976 *I'm Lost,* color, 25 mins.
The Selling of a Video Artist, color, 4 mins.
I Am Not Blind, color, 4 hrs.
Disposable Monument, color, 17 spots, 30 secs. each
If I Graduate, color, 2 mins.
A Portrait of Lita, color, 25 mins.
Dinner in Amagansett, color, 25 mins.
Birds Birds Bears Bowling, color, 30 mins.
Game Room, color, 40 mins.

1977 *Buy This Idea,* color, 16 mins. 27 secs.
Dear Post-Production Artist, color, 2 mins.
Fried Eggs, color, 1 min.
Diamond Mind, color, 30 mins.
Mott Art Theme, color, 1 min. 33 secs.
1000 Words, color, 1 min.
Stamp of Approval, color, 11 mins.
Les Levine's Cornflakes, color, 30 mins.
Ah Yes, color, 1 min.
What You See, color, 1 min.
Hand Shake, color, 1 min.
No You Didn't, color, 1 min.
What We Need, color, 1 min.

1978 *House of Gloves,* color, 5 mins.

1979 Deep Gossip, color, 54 mins.

1980 *2 Yous,* color, 38 mins. 48 secs.

1981 *Goju Jeff Lew,* color, 20 mins.
Visions From the God World, parts I–V, color, 31 mins. ea.

1981- *Mike and Liz Making Pictures,* color, 24 mins.
1982

1983 *Einstein: A Nuclear Comedy,* color, 22 mins.
String Instrument, color, 30 mins.

1984 *Vote for Art,* color, 3 mins.
Made in New York, color, 25 mins.

1985 *Anxiety, Religion and Art,* color, 22 mins.
Media Mass, color, 8 mins.
Everychild, color, 3 mins.

1986 *Trade Wind,* color, 26 mins.
Close Frenzies, color, 26 mins.

1988 *Rays,* color, 31 mins.
Misty, color, 3 mins.

Officers
Thomas R. Kennedy, *President*
Thomas Lucey, *Vice-President*
Stephen L. Johnson, *Second Vice-President*
Joan Green, *Secretary*
Mrs. Michael Falcone, *Assistant Secretary*
William Hider, *Treasurer*
Irving Schwartz, *Assistant Treasurer*

Trustees
Chester D. Amond
Mrs. Aminy I. Audi
William C. Egan
Alfred J. Flanagan
John S. Hancock
Mrs. Robert Hill
Patricia Humpleby
Bruce Kenan
Horace Landry
Betty Lourie
Edward McNeil
A. Fenner Milton
Mrs. Charles Morgan
Eric A. Mower
Dr. Umesh Patil
Mrs. Bernard Piskor
Daniel Petri
Arthur Pulos
Dr. Ernest Sarason
Mrs. Martin Shellenberger
Mrs. Robert Theis
William Tuck

Honorary Trustees
Mrs. John Chapman
J. Stanley Coyne
Carol Damico, *Ex Officio*
J. Murray Hueber
John F. Marsellus
Robert Riester
Mrs. John Williams
Mrs. Laurence Witherill
Thomas Young, *Mayor of Syracuse*
Nicholas Pirro, *Onondaga County Executive*

Staff
Ronald A. Kuchta, *Director*
Sandra Trop, *Associate Director*
Sara Ridings, *Executive Secretary*
Peter Doroshenko, *Curator of Paintings and Sculpture*
Barbara Stone Perry, *Curator of Ceramics*
John Rexine, *Registrar*
Michael Flanagan, *Assistant Registrar*
Kristine Waelder, *Development Officer*
Mary Carchedi, *Membership-Development Secretary*
Thomas Piché, Jr., *Public Information Officer*
Terrie White, *Curator of Education*
April Oswald, *Librarian-Archivist*
Helene Miglierina, *Volunteer Coordinator*
Carole Burke, *Office Manager*
Trina Powers, *Accounting Manager*
Jean Snow, *Manager, Sales Gallery*
Nancy Scherrer, *Manager, Luncheon Gallery*
Jorge Rodriguez, *Chef, Luncheon Gallery*
Gussie Will Alex, *Building Superintendent*
Rapha Johnson, *Building Staff*
Manuel Burgos, *Building Staff*
Donna Dreverman, *Guard*
Charles Kempf, *Guard*
James Perkins, *Guard*
Anthony Prince, *Guard*

Afterword
An exhibition of the complexity of *Public Mind: Les Levine's Media Sculpture and Mass Ad Campaigns 1969-1990* could not have been realized without the cooperation of a number of individuals and organizations. Many thanks are extended to Les Levine and Catherine Levine for the many hours they graciously consented to share with me for the realization of this project. Their unflagging hospitality and cooperation affected virtually every aspect of this exhibition and I am greatly in their debt. I am also grateful to John Perreault, a friend and colleague, who kindly consented to offer his insights on Les Levine's early career. I am also keenly appreciative of Victor Gisler who cooperated in every way to help finalize the European aspects of the exhibition. In Syracuse, the outdoor segment of the exhibition, the actual media campaign, would not have been possible without the cooperation of Penn Advertising. Both Richard Hubeny and David Pridgen are to be thanked for their support of the arts and their community spirit.

The administration and staff of the Everson have done a remarkable job in the presentation of *Public Mind: Les Levine's Media Sculpture and Mass Ad Campaigns 1969-1990*. Ronald Kuchta, director, and Sandra Trop, associate director, of the Everson have played key roles in the realization of this exhibit for which I thank them. I am grateful to Peter Doroshenko, Everson curator, for his professional support and collegiality, and my gratitude toward Tom Piché, public information officer and catalogue overseer, is as usual, boundless. To Carole Burke, long standing office manager, I offer my thanks for her professionalism, as I do to John Rexine, Everson registrar, for having handled with his usual care all the shipping and logistical aspects of the show, and to Kris Waelder for her grantsmanship. Thanks are also extended to Gus Alex, Mannie Burgos, and Rapha Johnson for their installation expertise.

I am grateful to all the lenders to the show, including Horst Schmitter, Reto Fehr, Leo Waltenspuhl, Theodore von Oppersdorff, Brigitte François, Galerie Brigitte March, Stuttgart, Mai 36 Galerie, Lucerne, and the FRAC Bourgone, Dijon, France. And I offer my sincere thanks to the National Endowment for the Arts and the New York State Council on the Arts for their generous financial assistance.

Finally, I would like to express my thanks to V. Walter Odajnyk for his critical insights and to Ann McCoy for her continuing support throughout this project. DN